PENNY RIMBAUD

PENNY RIMBAUD
A RE/Search Pocketbook
©2014 RE/Search Publications/Penny Rimbaud
ISBN 978-1889307-41-1

PUBLISHERS/EDITORS: V. Vale, Marian Wallace
COVER DESIGN: Judy Sitz
BOOK DESIGN: Marian Wallace
INTERVIEWS: V. Vale

RE/Search copy editors, staff & consultants:

Julia Trechak Whitney Ray
Kelsey Westphal Gail Takamine
Andrew Bishop Gloria Kwan
Emily Dezurick-Badran Beth Cooper
Robert Collison Karlo Pastella

RE/Search Publications
20 Romolo Place #B
San Francisco, CA 94133
(415) 362-1465
info@researchpubs.com
www.researchpubs.com

TABLE OF CONTENTS

INTRODUCTION by V. Vale

At heart Penny Rimbaud is a philosopher and seeker for the secrets of life and creativity. We hope his thoughts will inspire readers to "change life," as [Arthur] Rimbaud put it.

Since the Sixties Penny Rimbaud has written poetry, journals, prose, produced drawings, lectured, and read poems aloud in dynamic performances (someone called him "The Allen Ginsberg of London" for producing an updated version of "Howl," the poem that launched the Beat Generation).

But Penny Rimbaud is probably most famous as the drummer, conceptualist and lyrical founder of the proto-Punk band CRASS, which in a pioneering D-I-Y ("Do It Yourself") spirit produced their own vinyl albums, including dazzling poster-size artworks highlighting the graphic art created by co-founder Gee Vaucher, hand-inserted into plastic sleeves distributed by early Punk record label Rough Trade of London. Lesser-known is the CRASS promulgation of vegetarian diet, which caused thousands of Punk "anarchists" to identify with vegetarianism. And noteworthy in the long term is the Crass experiment with collective living on a farm producing regular crops of vegetables, titled "Dial House." Penny is an amazing improvisatory cook as well as a baker of hearty home-made bread...

—V. Vale, RE/Search founder

The Counter Culture Hour Parts 1 & 2

▮ V. Vale: Welcome to the Counter Culture Hour. I'm your host, V. Vale. I've been doing counterculture publishing since 1977 with *Search and Destroy*. Today we're especially privileged and happy to have with us all the way from London, England, Penny Rimbaud, most notorious for being in one of the hardest-core so-called Punk bands, named Crass. Since then, he hasn't stopped creating. He's produced a ton of books and he does incredible readings of his poetry. He's an all-around provocateur in the best sense. So welcome, Penny Rimbaud.

■ Penny Rimbaud: Thank you.

▮ VV: Okay, so Penny, tell me: what were you thinking about when you walked downhill to our office this very morning?

■ PR: Well, interestingly, **I was thinking absolutely nothing at all.** I had actually ended up at Caffé Trieste, and I was sitting there and was suddenly aware—which, in a way, denied the state—that I had at last in my life achieved a state of *no mind*. So I hadn't thought anything at all from the time I really woke up, to the time

I got to Trieste. Then I *did* think. I thought, "How nice! No mind," which doesn't mean that thoughts *aren't* going on—thoughts go on of their own accord—but it does mean that I don't *attach* myself to the thoughts so the thoughts don't attach themselves to the mind, and therefore don't become threads and complications and psychologies; they simply meander off with a bird song. That's what I was thinking (or not thinking) when I came from the top of the hill to the bottom of the hill, in short.

▌VV: Don't tell me you actually reached Nirvana [laughs].

▌PR: No, I don't think so, but I certainly have made a big step towards being able to free myself of psychological entanglement, which is what I've been working on hard for the last year and a half. For a long time, I've intellectually been able to say that I reject the Freudian psychotherapy issues—the lineation of psychological states— because I feel that unless one can destroy the multiple dualities of psychological states, then one can't achieve the *whole Being.* It's my own view that the 21st century will be viewed as almost as *vile* in its consideration of the human mind as the medieval witch-hunt era, where certain ways of thought, certain ways of imaginings,

were considered *devilry*. Well, I mean that's precisely what psychotherapy and the whole Freudian school demonize: states of mind. All states of mind are by nature creative because the mind is creative by nature. If we are unable to understand or follow those imaginings, then it's we who will suffer.

And I do believe that the parameters drawn by Freudian analysis and all of the psychoanalyses that have followed that era have actually created tight parameters that most people must suffer now in terms of social, intellectual, and emotional behavior. Whereas intellectually I have for a long length of time been aware of the damage done through *definitions* of mental states, it's only very recently that I at last feel I'm free of psychological entanglement.

■ VV: That's so odd, because it's only been in the last few years that I've kind of started to realize that consciousness *can* reside in the *body,* not just the brain, as a machine, and that memory might also be distributed through the body. You know, if you broke your little finger at age three and you suddenly not necessarily re-injure but remember it, you can be transported back to that state of mind when it happened, which you wouldn't consciously remember.

So I know there's a dichotomy between conscious and unconscious *out there*, but I prefer to strive for almost a seamless integration of both somehow. It's funny, I've never thought of certain psychological states as having names attached to them.

■ PR: **One of the things that has kept bumping up for me is the idea of "Before-ness."** Before the "I" of Descartes' "I think, therefore I am." The "I" must be a presumption, and it *is* a presumption, and I was interested as to how one might operate ahead of that—in other words, "before the 'I,'" which of course is *the great silence,* and to what degree one could operate in the so-called material world within that silence. Of course, one *can't* be within that, because it is of infinite scale, and one is simply *it.* So even to think of being within it is effectively to take up a Cartesian position—the "I" is still trying to imagine itself within the situation rather than *being the situation.*

Whether or not one can achieve any form of human communication in the Before, I don't know. I'd like to think one possibly can, but that's still a conundrum for me. I certainly know that one can exist in the Before, or *not* exist—I have to keep saying that. One can't possibly exist

in the Before because one is *either* the Before or *not* the Before. And one doesn't exist in it. One simply evaporates into it and becomes the *immortal nothing* and *immortal no one*.

■ VV: Well, you know, I'm just trying to figure out what humans or pre-humans were like before language slowly evolved. **Language had to evolve one word at a time**. I was thinking, instead of "I think, therefore I am," maybe it's, "We think, therefore we are." But I don't think that was very funny—

■ PR: Clearly, that's a necessary factor. The "I think" is fairly irrelevant. The "we" is at least sort of slightly more moving towards some idea of *symbiosis*. I mean, if there is anything out there, clearly it's a symbiosis, and one has to keep repeating "*if* there is something out there" because there's absolutely no substantial proof that there is anything out there—we simply *assume* that, and we *know* that it's nothing but our imaginings...it *can* be nothing but our own imaginings. It is the name we give it, and through giving it, so it takes form.

I tend to sort of just be willing to play that *theater*. I don't try to destroy that theater because that theater, it seems to operate in some way. One can operate in it. *In it.* I haven't

as yet created an argument about that, but nonetheless I'm perfectly aware that there is *nothing* but imagining, and the entire material world is nothing but a series of attitudes. It *can* be nothing but a series of attitudes. We will only recognize what there is to be recognized through our own states of mind.

Where you go from there is another matter entirely. But I think—whether language has been *de*structive or *con*structive is another issue—I suppose I've been a *de*constructionist most of my life, trying to remove falsely imposed ideas so I can arrive at some sort of authentic, qualitative existence. And certainly I am aware that that qualitative existence is divorced from "word" in any conceptual way. It could be interesting to say, "What can word be if it isn't conceptual?" In other words, it's simply the flamboyancy of sound, as the flamboyancy of music, which—I tend to think that the sort of metaphor of poetry is that it's something that doesn't attach itself to the *pragmatic* use of word. It asses around with word, it changes it so that the word that is spoken is actually lost in the word that is sung, if you see what I mean, which is why **I *pretend* to prefer metaphor. Metaphor is a more musical, less-defining, and therefore less-**

limiting form of language.

■ VV: Well, I'll say that William Burroughs once said that **"Language," meaning words, "is a virus from outer space."**

■ PR: Yeah. Well, I would be more inclined to think it's a virus from *inner space*. In other words, the inner space that we have, we fill up that inner space or *are filled up through* conditioning, by our prime conditioners, who are our parents, our schools, our religions, etc., who fill up that space with *nonsenses*. And which is why I said earlier, my whole life has been involved in deconstruction, in *removing* the detritus that was imposed upon me by what my father used to call the "real world."

And you know, we all know perfectly well that the "real world" in any particular culture simply exists through a hypnotic state of agreement, or a state of agreement that is gained through hypnosis. It has no substance whatsoever, and if it has no substance, it has no matter, and *if it has no matter, then it doesn't matter*. It sounds glib, but I think there's a deep truth in that. It interests me greatly that *quantum* is increasingly, effectively, breaking down any idea of *construct,* as construct is the result of observation, not of existence or of essence.

I've taken the existential position for a large amount of my adult life—existence before us or proceeding us—I think there might be a fundamental mistake there because **I think there might be no "essence" whatsoever.** There's no, as I understand it, there is *absolutely* no proof or substantial evidence to give rise to ideas of essence because it is all through observation. We are *always* the observer. That is unavoidable. What is avoidable, what is questionable, is the existence of any matter within the observed. It sounds like one is sort of assing around, but profoundly, through my own experience, I'm more and more conscious of the *flux*. If essence has any matter, then it's very clear to me that it's in absolute flux, and the only stability in it is that which I give through my observation of it.

▎ VV: I've devoted practically zero time to the question of the word "essence." I'll have to think about that one. But I come from the Surrealist viewpoint, which is that we're born with all these incredible potentials for creativity, and words are tools of creativity. You make drawings, but you need paper and pen or pencil to make them, otherwise they stay inside you, you could say. So that's another potential you're

born with. You're born with this great theatrical potential to give very expressive poetic readings, which many people don't seem to be able to do. And then, you seem to have the potential to be a philosopher, i.e., someone who's constantly questioning the meaning of everything and how everything is interconnected in the world—

■ PR: But the *less* you are the more you are, in that sense. If I were to consider myself to be any of the things you're saying, then I'm already restricting the potential that exists outside of that. Potential is by nature and by definition infinite, and we all have infinite potential. That infinite potential is *not* linear. It isn't contained within the confines of space and time. If it *is* contained within the confines of space and time, actually it ceases to be potential. **Potential is backwards-moving, forwards-moving, upwards- and downwards-moving. It is multi-directional.** So at any given moment—you were saying how one might be able to return to an exact imagining of breaking your finger when you were three— equally I can return to an exact imagining of my *death,* because, by nature, those things are already defined. Just as I was born on a certain day, certainly I *will die* on a certain day. The fact that at this moment I'm unable to say whether

it's tomorrow or in ten years time is irrelevant. The fact is it can only happen when it happens and will happen on a defined date.

So any consideration, one could argue, is sort of…reasonably irrelevant within that framework, which isn't a fatalistic point of view because to talk about it or to define it, to abstract it or to construct it, has no effect whatsoever within the general and overall *symbiosis*. It can only be as it is at this given moment.

It seems to me that one of the sort of *failings* of consciousness is to say, "Well, it can only be as it *is*," as a statement of victimhood, as a statement of suffering. I mean, I have a strong argument with the Buddhistic view, "life is suffering," I mean, that is absurd, life is *not* suffering, it's quite the opposite—it's nothing at all. It's only suffering if one is involved in the turmoil one creates *of* it. Inevitably, if you stir up a tub of water, the water is going to be disturbed. Well, we *are* a tub of water, in the symbiotic, in the sort of cosmic level, you know, so *do unto thyself.* We're sort of *set* into this role of being the victim of life, a well-I-never-asked-to-be-born sort of syndrome; you might just as well say "I never asked *not* to be born," it's quite an irrelevancy. And the idea that there's any importance

whatsoever in one's sort of *manifestation*, it's a conceit. It *can* be nothing *but* a conceit, a vanity. Remove those elements and **one simply is the drift of life, whatever that is**. The moment one tries to attach *any* sort of importance or meaning or value or judgment into that, then actually one ceases to be the drift of life and becomes some sort of absurd manifestation of imagined static, as I understand it.

▍ VV: You mean imagined *status,* perhaps—

■ PR: Yeah, yeah, yeah…yeah.

▍ VV: Well, I…I keep saying "I" but now I am very self-conscious about using the word "I"!

At RE/Search headquarters

■ PR: Well, one has to, so…unless one uses the royal "one." But one is bound to do that…

❚ VV: Or the royal "we!"

■ PR: Oh, the royal "we"—yeah! [laughs]

❚ VV: You know, I like your concept of the universe as some huge symbiosis, and I think I've tried to not just be imprisoned by the confines of my own so-called ego. I think I strive to continually be putting myself in the larger context of space and time and the entire universe, and I realize we are in a time continuum, which I suppose—

■ PR: Well, we are *not* in a time continuum. I mean…the prescriptions of Enlightenment thought tied us to that as a sort of *identity*. It is necessary if we are to exist in this form of identity that we believe these certain formulas. Certainly time-and-space is a direct result of that "I the thinker, I the seer, I the observer," the "I, I, I." I don't know a great deal about pre-Descartes thinking, but I'm very aware it was considerably more fluid, far more inclined to take off into **the so-called "mystical" realms, which weren't bound within time and space**.

I mean, in the few underdeveloped or truly developed places in the world that I've visited, particularly Africa, time is something that expands and contracts…infinitely. Linear time

does *not actually* operate, it doesn't work. It's pointless to try to apply it, and if you do try and apply it, you get into some serious messes, or you get into serious messes of frustration for a start. Things *happen* in their *own good* time, and if, actually, one is willing to engage in that *good time*, things will happen accordingly and correctly. For example, I remember on one occasion where I was leaving Africa, I had a plane to catch, I had probably something in the region of four hours to travel from the village that we were staying at, to the airport. In western time, it probably took us ten hours to get from the village to the airport, and the plane should have gone six hours earlier, but there it was waiting for us. That is because we were acting *within* the expanding time, or *non-time*, which will accommodate entirely. And I've learnt working on the land that time will always create itself to allow the purpose that one has placed for oneself within that framework, because there's always time to do the job I set out to do. Whatever time I start, time will expand to allow me to finish. Meaning time…eventually it will get too dark to be able to do something, but that never happens because I always finish before it gets dark, and it's not because I'm trying to beat time, it's

because **time expands, you know?**

The whole idea that time is a sort of set—I mean, I wear a watch because that is part of the theater of operation within a given world… but it is a *given* world, and if you're in the West, then it's the given world that is most commonly agreed to, so it's best to commonly agree to *do* it. But to imagine that this actually is a *de facto* operating truth is absurd, because it isn't.

▌ VV: You could almost argue there are as many different worlds as there are people—

▌ PR: Certainly.

▌ VV: [laughs] Also, I think **I've never been comfortable with the notion of identifying my body with "me"**…I don't know if you ever thought about that, or if it's even important—

▌ PR: You mean, do I…does the "I" represent the body that carries that idea?

▌ VV: Look, you've gotta admit, you've got your own unique DNA, your own unique RNA, which means wherever the memory cells in your body that preserve memories are, these memories are encoded in your alleged RNA cells.

▌ PR: Yeah, but I do actually believe we have the potential to *completely* restructure those.

▌ VV: Oh, the brain, sure. The brain is amazing—people have had little parts of their

brains removed, and the brain constructs work-arounds so they can function. I think we are marvelous… **there's a huge amount of marvel in every person and many people don't seem to really value themselves enough**.

■ PR: I think that one of the obvious arenas is that of disease, so-called "dis-ease" disease. And I profoundly believe we are perfectly equipped not to control, but to embrace disease in a very different way than how, generally speaking, people in the West *don't* embrace disease. They actually go into *battle* with it, and what they're doing is going into battle with themselves, 'cuz it's themselves that's ill. They are creating an extreme form of duality and they will suffer for the consequences, and frequently *do* suffer the consequences. The consequences being the dereliction of pain—I mean, pain is an exquisite feature of life, just as whatever the opposite of pain is—pleasure! It's a unique and beautiful possibility, and I certainly realized that during my period of severe illness. I could argue that I did not *want* to be in pain, but the "I" would equally argue that I did not want to be in a constant state of laughter. Because actually there's a great similarity between those two extremes, you know. **Extreme joy is just**

as sort of deadening as extreme pain is to everything else. It's a very…it's a huge take-on.

▌VV: You mean take-over?

■ PR: Yeah, I mean no, it is a take-over, but it's *we* who are doing it, so it's a take-on. And I think the whole idea that there's something that isn't us that we can *treat* as something that isn't us and actually *give over* to other people to treat as something that isn't us… "How are YOU feeling" and those sorts of strange absurdities, I mean, "WHO are you feeling" might be a better way of putting it, or "WHY are you feeling" is an even better way.

▌VV: And "WHAT is doing the feeling?"

■ PR: Yeah, yeah.

▌VV: Little nerve synapses are sending messages up these amazing passageways to your brain, and yeah, I think humans are marvelous, we are "fearfully and wonderfully made" [laughter] to quote somebody way back in time, in a book that I've partly disavowed called "The Bible." Long ago I had a problem with calling it *the* Bible because that seems to imply that there's only one. But then you could also argue that every book that's ever been written is part of one huge book, which is sort of a mash-up philosophy that's kind of contemporaneous…like, there've

been predictions that **when every book that's ever been written will be available for free on the Internet, there'll be the most infinite mash-up there's ever been**.

■ PR: Well, it certainly would be interesting if one *could* include *all* written word that has ever existed on the Internet and then put it through a sort of filter, so that... you could create a program that would go to a particular idea, a particular concept, and actually sort of come up with the praxis or synthesis of them. To see the result certainly would be fascinating, because **everything is just some form of repeat**—it has to be. Nothing comes from nowhere, so...

▌VV: ...And something comes from somewhere. You could also say that—I know I've read about a computer program out there that allegedly creates "poetry" out of all the poems in its database. Burroughs did cut-ups, and before him Brion Gysin did: literally cutting up newspaper columns and adjusting and restitching the words together. Sometimes they claimed to be prophetic, to predict things.

■ PR: Well, I think that's absolutely right. I think that's even more achievable through the operation of the known mind. An unleashed mind will do the same, which is why a so-

called psychotic is very liable to be *highly* intuitive, *highly* able to make sort of prophetic remarks because they are actually unleashed, so therefore the breadth of their attack, if you like, is far greater than the average, highly confined, parametized individual. Psychosis is a break out of individual restriction into a sort of broader field, which can be dangerous, or it can equally be whatever *the opposite to dangerous* is.

▌VV: It can create art, actually.

■ PR: Yeah, totally. To go back to the beginning of what we were talking about, what I seek is *breadth*. Then I realized a much quicker way of arriving at some sort of breadth, and I would say that possibly Buddhism aims at a sort of breadth, and I think Zen goes that much further in broadening... The whole concept of Beforeness sort of circumvents all of that. Because one isn't engaging in the first place with the Descartian individual that has to sort of bit-by-bit free itself from itself, and there are lots of practices available in any bookshop or anywhere you wanna go—you can sort of trick the Cartesian "I" into becoming broader. *But* it seems to me that there is a simpler way and that's when quite simply one enters into the equation "*BEFORE* the Cartesian 'I.'"

▌ VV: I think it's pretty abstract to start trying to envision *"before* the Cartesian 'I,'" if I'm a personality—or maybe my personality is just an *illusion.*

■ PR: Well it certainly is, and it's your personality that—not *yours,* I'm not...this isn't personal—*one's* personality is the very thing that doesn't *want* to engage with any concepts of Before because, quite simply, it will be vanquished. You know, we imagine that it's our personalities that make us the charming people we are, or the persons we imagine ourselves to be in other people's eyes. Well, I believe that that is a profound mistake, because **the more highly developed a personality is, the more rigid it becomes** in fact. The more unattainable, the less easy it is to *fuse* with highly developed and highly practiced personalities. I mean, one reason it's so easy to confer with bums in the street is because they've got very little to hang onto. Doesn't necessarily mean one is going to have pleasant conferences but it does mean that there's very little to hang onto. There's an immediacy that can go any way, you know, it's far more like sort of swimming across a river rather than rafting across it—well, I want to swim through life not raft on it. Because swimming through it, or being

of it rather than in some way rafted *against* it... being in the great big ocean liner when really we all exist as the sea is a rather silly thing to do.

One could look at the institutions of democracy, politics, as being just huge warships or liners floating on the Ocean of Being and denying all its occupants with these ridiculous things like "WE are a democracy" and ways of ensuring that we stay *on deck*, and don't *dive* off the side. We will only become a democracy when everyone dives off the side and the boat drifts away empty. *Then* we will be a democracy. As long as the boat will have its little "Titanic" written on the side, we all know where the Titanic's going—well that's the nature of *any* form of political institution. It is *bound* to its own destruction, and it is bound in its own destruction to carry all of its inhabitants with it.

■ VV: Yeah, but what if you're someone like me who doesn't know how to swim and never learned? [laughter] I don't know why I don't wanna die, but I'm trying to be like Woody Allen who said, **"I'm not afraid of death, I just don't want to be there when it happens."**

■ PR: [laughs] Well I don't have any fear of death whatsoever, because, I mean, effectively, we're already dead, and we are of nothing—we came

Lapo absorbs—Gee Vaucher's Grant's Tomb opening

from nothing, and we will continue in that state. I don't *actually* see any difference between the state of life and the state of death. I've already said that I regard pain as being an exquisite part of human existence, which doesn't mean that I just sit there if I'm in great pain and smile, 'cuz I can be sitting there in great pain with tears

rolling down my face, but I mean I don't—I have *no* consideration whatsoever, or pressure *against* my own death, I mean it's of no consequence. **I have been of no consequence and I will remain as of no consequence.**

I think the only thing we're trying to *protect* is simply an idea of self, and that idea of self is so frustrating. I mean, people *don't* live a life because they fear the very inevitable—I mean there is one thing that is going to happen to us all, and that is we are all going to die. Most people live in fear of that—well, then they live in fear, so they never actually *live.* **It's almost paradoxical,**

Gee and Penny at Winston Smith's Grant's Tomb art space

**and it's certainly contradictory. You can't
live a true life if you live it in fear of death,
yet you fear death because it's going to
stop you from living a life**—well you're *not*
living a life because you're fearing death. You're
certainly not living a life to the full potential of
existence because already you've limited it by
your own fear.

The institutions, in any case, they govern
through fear. I mean all media is involved in
instilling fear. I would say almost sixty percent
of all human communication is about the
instillation of fear, the maintenance of fear,
because that's how people *believe* they exist.
**People enjoy drama, they enjoy tragedy,
they enjoy all of the negative aspects
because that actually makes them feel
better.** That's a form of victimhood; it's always
self-contradictory, but more importantly it's also
life-destroying. And that's why we started this
little part we're talking about, saying, "You're
already dead, we are already dead." The fact that
we might choose to use our imaginings to say
otherwise is fairly irrelevant.

The state that exists here in this very moment
is exactly the same state that would exist when
we're *not* here at this very moment. We are not

either taking from it or giving to it, we are simply *of* it, and we will continue in whatever way to be *of* or *not of* it—the law of physics, or of energy, maintains that it is impossible to "remove." Well you cannot remove, and one is not removed. I'm not a life-after-deather at all, you know—that's ridiculous, because the life that people talk about when they talk about life after death is actually a conceit of the mind. Well, the conceits of the mind will not survive death, and that's for bloody certain. That can be proven neurologically or in any way you want—it will not and cannot exist. And as *we* are conceits of the mind, the "we" that is the "I" or the Descartian individual, then to start creating fanciful ideas that that silly conceit is going to somehow survive death is just an absurdity. What certainly survives is the fact that nothing changes: the energetic field will move off into other areas, other generations, other manifestations... and god bless it on its journey! [laughs]

▌ VV: But actually, everything changes all the time and *is* in a change of flux. I like those sixth-century B.C. philosophers Heraclitus and Lao Tzu who made statements like, **"You never step into the same river twice"**—

▌ PR: That's right, absolutely.

■ VV: Now one of *the* important priorities for me is humor—humor is *really* important.

■ PR: Well I actually think that deep humor is in that absurdity. You frequently say, "Why

With Jello Biafra at Grant's Tomb

am I laughing?" and I do laugh a lot. I do *not* laugh very much about human comedy because human comedy is a comedy of errors, usually. Laughing at other people tripping on a banana skin is just not funny to me, it *doesn't* amuse me. I'm not saying—

■ VV: [laughs] Why am I laughing?

■ PR: [laughs] Yeah. Most jokes are at the expense of someone or something, and that doesn't amuse me. What does amuse me is the sort of *absurdity* of my own and other people's actions, the simple movements, and the sense of *meaning* being fabricated. When the conjurer draws the rabbit out of the hat and we laugh, well I find that with just about anything. Everything is a rabbit coming out of a hat, whether it's what someone says or the way that piece of wire is over there. So **I actually think the entire manufactured universe is a massive joke**, and I don't mean that in a cynical way, I think it's *hugely* funny in the deepest sense. It's the belly laugh of the Buddha, the true "ho, ho, ho," which is manifest in everything. At the same time, there's a strange manifestation of the *opposite*. There are tears in everything, everything is passing away as much as growing, etc etc etc. I certainly do *not* ignore humor, I am humorized *massively*, simply by the pure absurdity of existence. That's what makes me laugh more than anything else. I don't laugh at jokes because most jokes don't seem to me to be very funny.

■ VV: I'm a fan of cosmic humor, of black humor. Black humor to me always brings in some other darker principle—

■ PR: Yeah, yeah…

▌ VV:—that's not immediately apparent. **Black humor is more cosmic to me**.

■ PR: I agree. If you mean by cosmic, universal, which I think you do.

▌ VV: And Shakespearean.

■ PR: Yeah, well Shakespeare was the master of the universe, and I think that that's partly because he had the great benefit of really pre-empting *mass* culture. In the same way as Mozart had the *privilege* of being very early on in scored music, Shakespeare was very early on in the printed word, and so it hadn't become so defined, the parameters hadn't been so drawn, and therefore it wasn't in any way as *limiting*. And if you then look at the parameters drawn by Freudian psychology, which again, *really* put the thumb-screws on to defining human states, etc etc, well all these things are just *limitations*. On the one hand, there's the sort of aspect of [mocking tone] "Well, we're learning *more* about things"—well actually we're learning *less* about them, you know. If you compare the magnificent breadth of Shakespeare to any modern writer, you'll be saying, "What happened?! How did all that go wrong?"

There are a few people who *have* risen to those

heights—I think Walt Whitman in America came close to those sorts of magnificent heights, and the Romanticists in England, etc etc, but *few*, only a few have risen to that *breadth* of vision—few have *dared*, which is really what it's about. The fact that under Freudian principles, Cathy and Heathcliff could not exist and have not existed—there have been no two romantic heroes on that level that could *instruct*. **I think Wuthering Heights is a very instructive document about the nature of passion, the dangers of passion, the joys of passion**, et cetera, actually **the deep meaning of passion**. I mean, both Cathy and Heathcliff, by modern definitions, were *psychotic*—there's no question of that! Well it's our loss that we are able to see them in that light, and I think that that's given rise to an awful lot of *cruel literature.*

A lot of modern novels are quite simply cruel because they cannot any longer countenance the totality of human experience, because that's what Freud knocked on the head—he compartmentalized human experience. To be able to say that love and hate are separate emotions is quite absurd, because they are one and the same and they actually manifest in almost identical ways. So really, the idea that—

I'm not saying that *you* have made that idea—but **the common idea that we are "progressing" in some way is quite absurd**.

In my view, general culture is becoming tighter and tighter, the parameters are actually becoming tighter and tighter, a bit on the level of the political "war on terror," which actually has allowed the states that are operating a war on terror to terrorize their own populations to a greater scale, I would say, than Nazi Germany.

▮ VV: I suppose there are mini concentration camps known as Abu Ghraib—

◼ PR: Well, *mini concentration camps?!* Over a million incarcerated blacks in America is *some concentration camp.* The scale is massive. The whole nation's incarcerated in Iraq, and in Afghanistan. With the total felonization of one particular race, I mean, who needs *gas* chambers? The simple and horrible and frightening fact is that America *doesn't need* gas chambers.

▮ VV: I never thought of equating jails with concentration camps, but when you start adding up the numbers—

◼ PR: Well it's not a matter of numbers, it's also a matter of racial similarities. I mean what's happening in America at the moment is certainly on a level with what has become known as the

Holocaust—

▌ VV: Or America putting the Japanese in camps which they architected and built in advance—

▌ PR: The only thing they haven't started practicing yet is mass extermination. Well, one might remember that neither did the Nazis, until they were under threat from outside. There was a degree of death, but essentially they were work camps and they were kept operating for as long as possible. When they were finally under threat, then the *mass* mass extermination started. I *might* be slightly wrong on my history there, and certainly the exterminations had started long before that, but that was within the framework, the almost *eugenic* framework in terms of the unusable, the mentally ill...

▌ VV: —the gypsies, the gays—

▌ PR: Yeah yeah yeah, which actually was a philosophy that was developed in America and Britain way before it was taken up by Nazi Germany.

▌ VV: Oh, eugenics you mean? That whole idea of the master race and all that?

▌ PR: It was a British and American thesis that Hitler applied. But that's happening currently here with the black race. Over two million felonized—well that's a huge number of people.

I don't know what percentage it is of the black population, but it's a pretty high one.

■ VV: It's definitely related to economics. In certain neighborhoods you will see a lot of unemployed, mostly black males, just on the street, because no one will give them a job. And **if no one gives you a job, how do you survive?** I mean, you fill in the dots... What do you think about words like "compassion"? It's not funny, but someone invented the term "compassion fatigue." [laughs] It's not funny, but here I am laughing. That phrase came into being because we're constantly barraged by appeals to give to this cause and that.

■ PR: I actually think compassion fatigue comes from a form of armoring. I don't think compassion can be fatigued, because either love is all or love is not at all. Compassion is love. There is a horrible and crippling truth in the land of America, in the U.S.A., which is the gradual and vicious extermination of the whole race and the whole black culture... which people feel impotent against, in "How the hell do you deal with it?" and that leads to indifference because one feels one *can't* do anything about it. And maybe one doesn't even want to do anything about the innate racism that comes into operation, etc etc, so nothing *is* being done about

it, and actually it's growing and getting worse all the time, effectively, through *indifference.*

There are possibly very real reasons for that indifference, but if you have indifference, then you will suffer compassion fatigue. Because actually what you're doing is trying to *contain* something, and that becomes stagnant, and there's the creation of fatigue. It's very much like physical illness: it cannot develop in an active body, it will only develop where there is fatigue, where there is a sort of *stasis* that occurs because *that* creates the bed within which cancer will grow and flourish. So either it's a traumatized part of the body—either emotionally or physically traumatized part of the body—which becomes stagnant, and it's within that stagnancy that the cancer develops, and it can be healed by locating the stagnancy. The cancer is irrelevant, the cancer is actually a game-player and is part of one's being, it exists already, it's always there, we've all got it in one form or another, ready to do whatever it does, and very effectively.

It's like rats. **The idea that humans could exist without rats is ridiculous**. They do a very good job of removing stuff, which is why they're never more than three meters away.

▌ VV: When I was a kid, I read a book *Rats, Lice,*

and History. It said that the amount of rats in any given country or place seems to match the number of humans—

■ PR: Well, yeah, it's true. I had a good thought just now, so we'll go on with that: Fear is lack of respect.

❙ VV: Res*pect?* What do you mean: fear is lack of respect?

■ PR: Well I was thinking about rats...

❙ VV: Rats?

■ PR: Yeah, and I mean, I used to think—well, there's two things: rats and heights.

❙ VV: And heights, like being up high?

■ PR: Yeah, and they're both things that I feared. I feared, so I was inhibited. My life was inhibited because I couldn't go up mountains, which possibly isn't particularly important, but I always used to feel a bit nervous, fearful, walking across the cow yard back home at night because the rats would be out. And certainly when I first lived in the house, there were rats inside as well, and I was fearful of them. And then I was thinking that really, I overcame my fear of heights by becoming a mountaineer, becoming a climber. I thought, "Well I'm gonna challenge this, I'm gonna do something about it, and the only way to do that is to *do it* and

go out there." And what I realized is that I wasn't in the least bit afraid of heights, I simply hadn't grown able to respect them. So I can now stand on a minute ledge hundreds of feet above ground, and of course I have a very sensible fear of falling, which I can do something about—I can put the right mat nuts in, I can tie myself in until I'm ready to climb again. I can use sensible protection, which largely inhibits any real damage one might do to oneself, etc etc. **In other words, it's by growing to respect the situation that one overcomes the fear.**

Well, similarly I had a fear of rats. On one occasion I came out of my shed in the garden to return to the house, and there was a very large rat squatted rather near the door into the kitchen, on its back feet, kind of sitting up. I thought, "At last, here's an opportunity to overcome my fear." So I sort of actually walked up to it in a way that one wouldn't normally to a rat and normally a rat would bugger off anyway, but this one didn't. What it did was let out a hideous scream and attack me [laughs]. So I backed off and eventually found a broom because it really was insistent, and obviously it was quite sick and so it attacked the broom. Eventually we managed to get a bin over it—we got it into the

bin and we threw it off into the cow yard so it could finish its life or do whatever it had to do. But anyway, it was actually disrespectful of me to imagine that I could, in some way or another, *embrace* the rat, you know—I mean, they're not there to be embraced. They're there to do whatever rats do, which is generally speaking to clear up human detritus and muck, you know; they're very useful for that.

So anyway, it just occurred to me because we had sort of just touched on rats that fear is *really* lack of respect. And if one looks at anything one is fearful of and can grow to respect it—I don't mean respect in the sense of therefore acknowledging and liking, but of respecting something for its *is-ness,* for what it is—then one is in a position, actually, to deal with one's relationship with it in a way that is not fearful, which is free to see and to understand and to interact in the way that things that do not have consciousness interact quite normally.

It always irritates me when people will say that a cat is cruel, for example, in the way that it plays around with things. It isn't cruel at all, it is simply doing what it does do. I mean cats play with mice, actually, until they break blood, and then they eat it, so the playing with

it is actually a method of breaking blood because until the blood comes out, their instinct isn't to kill, it's simply to play around, for some reason or other—I don't know what that reason is, but you know, 'cuz that's just part of the biological development of anything. But anyway, so, it's only sort of an aside, but **fear is always going to have a root in lack of respect**.

▌ VV: And hatred, too.

■ PR: Well that *is* lack of respect.

▌ VV: But it's funny how—

■ PR: Yes, no, that's absolutely right—

▌ VV:—how you did link hate and love being two sides of the same coin, and I've known that intellectually for a long time, but I still hate a handful of people very actively. I'm not sure how to overcome that but we won't go into that now.

■ PR: I mean, I think—and I rarely quote people—but Eckhart Tolle talked quite simply about how if you were that person, you'd know why. And I do very much believe that that's absolutely correct and "there but for the grace of god," and that the fact is that everyone is—it's something we were talking about in that Q & A the other evening—I mean, I *profoundly* believe that everyone's doing their best—

▌ VV: —including the people you hate? [laughs]

■ PR: Yes, no, absolutely, they are. One of my methods of dealing with one I *imagine* I hate—

▌ VV: Do you hate anyone?

■ PR: No. I—

▌ VV: Really?

■ PR: I absolutely do not.

▌ VV: No one who wronged you?

■ PR: No, no, no.

▌ VV: Well, **how do you deal with someone who wrongs you?**

■ PR: Well, they're *them*. I mean, it's sort of like trying to impose onto people conditions that are spectacularly different to what you impose onto most other things. I mean, if you drop a brick on your toe and you're alone you probably go, "F*ck it," and sort of kick it or something. If you drop a brick on your toe when there's someone standing next to you, you're very likely either to blame them or to get into some magnificent drama to impress them, to engage them.

I was given an incredible instruction once. It was an illiterate—and I don't mean that in any critical way—laborer, man of the land, who used to live on the farm, an old man who became a great instructor for me. I could almost go as far as saying he was a form of *guru* to me. He was completely uneducated, he had never traveled

any further than the land that he lived on, he was one of the laborers on the farm where Dial House is located. On one occasion we were putting a stake into the ground. He was holding the stake and I was doing the sledgehammer, and the sledgehammer came down on my thumb, and I was in absolute agony. He was completely unmoved by my pain and quite simply said to me, "Well, *I* didn't feel it."

Well that was a sort of huge instruction. Effectively what he was telling me is, there is no point whatsoever in blowing it out into the world: "I didn't feel it; you're alone in this, get *real* about it," and it was sort of a little *satori* for me. It was absolutely correct: I'm on my own in all of these things. Why manufacture them into [drama], why try to incorporate people into that drama? It's actually the complete opposite of compassion. What compassion does is try to flood *out* into all being, and what *that* sort of stuff does is try to incorporate [others] *into* one's own pain, *or* one's own joy, humor, or whatever it is—try to catch and draw people into *your* particular pathos, your particular demonstration, your particular drama.

I mean, I do and have for a long time regarded other people as like the weather: You can

complain about the weather but it's going to be the weather. Whether you complain about it or not, it makes no f*cking difference. You can be sensible and put on a raincoat if you're going out when it's raining, or not—it's your choice. But to complain about it is just absurd.

Actually, Enlightenment thinking gives a great deal of weight to complaint, constantly. I mean the whole program, the whole industrial revolution, the whole eugenics, everything has come out of this idea that we can improve on the given. Now, the average African village

doesn't attempt to *improve* on the given, it simply operates *within* the given. So it grows its cassava, it climbs up trees and comes down with coconuts, it smokes what's available, it doesn't make its roads better, they're simply tracks from one place to another and if they're full of mud, they're full of mud, and if they're not full of mud they're not, etc etc etc. So they're not trying to improve on the given, they *are* the given, and they operate within and *of* the given. Well, **the whole Enlightenment program was about improving the given**; eugenics was a desperate attempt to improve the given, like it or not.

The Holocaust was an attempt to improve the given, and that's what's happening. All of these injustices—not that there weren't injustices before the Enlightenment, but certainly Enlightenment has multiplied them. Certainly the idea of "I the thinker, therefore I the individual" has destroyed "community"—the individual within the community as a *problem* is a very Western, Enlightenment thought.

▌ VV: Well, with our technology, we make influence greater than we might have in the past. I'm thinking of the psycho killer who's gotten away with killing maybe thirty or forty people in different areas, and this psycho killer

City Lights

travels to avoid being caught, and his victims are prostitutes that no one cares about. And he has superior technology to overpower and kill people very fast... the psychopath is an extreme example of the individual alienated from society, who was once part of society because it got its food from society—

■ PR: Well, **one of the things a psychopath does is expose some of the contradictions and absurdities of society.** You used an *archetypal* situation of the psychopath and the prostitute, which does seem to be a pattern that has reoccurred. Prostitutes are essentially regarded as victims to be used and abused in

any way men choose to use and abuse them. [Psychopaths] might not choose to go quite as far as Jack the Ripper or any psychopathic killer who makes prostitutes a *program,* but it is actually stating how we treat prostitutes, which is with no respect and with no honor, so therefore they're fair game. It's a bit like the whole idea that the spoils of war include rape. You don't complain about soldiers who rape whilst killing because that's part of the program, it's written into the story. So the psychopath quite often exposes *serious* social flaws, exposes the lack of true compassion within any given society.

It's a bit like the innate racism of the USA *allows* for that guy the other evening to be in that state, and for it to be perfectly permissible

Everyone wants their book signed!

With Peter Maravelis City Lights events co-ordinator

for me, had I chosen to, to become abusive and call him some sort of [puts on belligerent tone] "f*cking derelict who shouldn't be behaving like that and what the f*ck's it got to do with me," etc etc. It is a part of the innate **racism** that exists in America, and in Britain and most Western countries, where it's actually perfectly acceptable to behave in that way. **There's a veneer of pleasantry, a veneer of acceptance**, and that veneer becomes easier to adopt when people are more willing to conform to "white" principles—but if they're *not* willing to conform to white principles, then they're fair game.

And people will use expressions like, "Well, they de*serve* what they get," and innately most people regard prostitutes in that way. That's an *innate* attitude, and there is little compassion. I mean, prostitutes would not exist if there were true compassion—they could not exist, because it would be impossible for them to offer their services in a compassionate society. Which isn't to say that people wouldn't involve themselves in sexual intercourse—they certainly wouldn't involve themselves in sexual intercourse that is essentially an *abuse*, however one sees it.

▌ VV: I won't take the side of sex workers who have a difference of opinion, but let's—

■ PR: Well *do,* because I mean, what they're trying to do is to make some sort of workable, healthy situation out of one that is innately prejudiced against any stance they might choose to make. Which is why they have to fight tooth and nail, however much the sex workers, in other words, the *illuminated* people within that profession, might *want* to do that. You don't need to look much further than the Mexican streets or the average streets in most cities and I'm quite sure if one wanders out here, you will find people from the poorer nations offering sexual services. I don't know whether that's the case here, it's certainly in—

▮ VV: Because of drug addictions, often.

■ PR: Yeah, well okay. I think that as well, so…

▮ VV: You said something earlier that I am still contemplating. First, you attacked the notion of progress, which I'm sympathetic to because it's often tied to technology and I'm not sure how much we want to get into how technology brings about so-called "progress" in society, the world, however you want to put it. But **there was an idea that ideas improve and our language improves, and I'm not sure if it does or not.** I would like to think that because of the incredible knowledge brought to many

low-income people through the Internet that it's possible to have a much bigger, factual picture of how the world is all interdependent and how it works. For example, there's a website that tracks how all the land in the world is used and who owns most of this land, and this could possibly bring out some reform or reframing of our future in which land is more equitably distributed, as far as distribution of resources to more people and less of the one percent.

■ PR: Well, I don't want to get particularly engaged over it, but I don't agree that information or *facts* give rise to action, necessarily. I certainly don't believe that some impoverished persons sitting in impoverished homes have got access to those facts—certainly the average citizen of Africa or India has *not* got Internet access. We like to assume the world's being governed by this sort of *great information service*—well, it quite simply is not. **Over three-quarters of the world does not have access to the Internet**. So it certainly means that the Western powers are more able to manipulate the people within their power, i.e., in the Western democracy, so-called.

Large numbers of people do have **Internet**, so therefore it is a useful tool both for the

dissenters and for the power-mongers, and I would hazard that **it is a greater tool for the power-mongers than it is for the dissenters**. Yes okay, so you can let people know there is going to be this, that, or the other. You can give all sorts of information about this, that, or the other, but that will always be countered by and overpowered by the fact that, I think it's 97% of men, have been active on pornographic sites. Well, I mean, that's appalling, really. I don't know whether that was in America and Britain or just Britain. The two biggest *arenas* on the Internet are pornography and gambling. Okay, so [mocking tone] "it offers an opportunity to be better informed"—well, at the same time it offers the opportunity for blokes to jerk off all the time or more than they might have done previously. I don't suppose it'd be more, they're just finding a different *tool* for jerking off. **You don't buy copies of *Playboy* anymore, you just turn on the computer**, you don't get the pages wet. So I don't really hold with that, and it's not a subject I particularly want to talk about—

▌VV: What, the Internet?

■ PR: Yeah, I mean, I think it's what any individual makes of it. I don't think it has the powers that we like to imagine. I mean, just as

you *know* of the absolute corrupted nature of so much of the material on it, you *know* that the Secret Services are spending *massive* fortunes on making sure that anything that comes up will be counted in one way or the other, if not disrupted in some way or another. You can't trust *anything* whatsoever on it because there is no authentication on any of it, so you might be thinking you are looking at a legitimate site when you're not looking at a legitimate site and there is no way of knowing, etc etc etc. And it is so…florid—I can't think of a better word to use—that it is actually of no interest whatsoever to me. **Information off the Internet is always pornographic**, in my sense, whether it's about Jean-Paul Sartre or how big the average Russian tit is, it makes no difference to me, it's all pornographic. I like books, I like dialogue, that's where I get my information from because I can trust it. I want some form of authentication before I will engage in any form of information.

I mean I *do* use the Internet for certain things like "what was the name of that café I went to in Paris" because I want to write about that café I went to in Paris, and it's very quick for that. Google search is useful in that sense. **My brother once gave me very good advice about**

the thesaurus: Never use a word you don't know, not immediately, anyway. I think it's the same—what comes out of one's head or through dialogue, you know, one authenticates simply through the process. Whereas going "Oh! I didn't know that!" is such a common sort of *thing* with the Internet. **You still don't actually know it, you simply got it off the Internet**.

And I think there's a huge danger to that. I know writers who spend their entire time minimizing the page to where Google is always there, they just need to press a button and up it pops, so they can ask the next question, and they'll produce entire volumes based on information coming off the Internet. They will always be specific. You can't ask questions like "What do you mean by that?" or "Could you explain why you're using that particular word?" which is what dialogue is about. It's a bit like imagining you can make a loaf of bread by learning off the Internet, but you're not going to get the smell of it, you're not going to get the sensual nature of it, etc etc, and neither are you going to get [sigh] *self-knowledge.* I think we carry everything that we need within us that we actually *need.* We don't carry what we *want* within us, but we certainly carry everything that

we need. We have all the intelligence we need, and we develop that intelligence as we need it.

Now, what we might *want* is another—that's why I don't like academics, because academics *want* more than they need. They can't see *not wanting* to find out *more*, but they don't *need* to find out more. And one of the things I don't like about academia is its lack of poetry. They reject metaphor in favor of so-called fact. So the pragmatic overpowers the metaphoric. And I think that the Internet has enlarged that. **Increasingly we're moving into a pragmatic universe, as opposed to a metaphoric one—**
▌VV: Or a poetic one.
■ PR: Yeah, a poetic one. And I believe that, for example, in Nietzsche or Whitman, one can find *everything*—or in Shakespeare, one can find *everything* one could *ever, ever* need in *all* of one's lifetime within those few words. I mean, *"Thus Spake"*...one doesn't actually need anything more than that, it's enough! And all the rest is sordid elitism.

So much art is not about compassionate engagement, but elitism; it's about, "Well, I knew better." You know, Pollock went within, he didn't go without, he didn't go outside, he went increasingly, increasingly deeper into himself.

He made what I believe are some of the greatest universal statements *ever* committed to canvas. Had he been looking outside to try and form or create some form of an elitist statement, then that could not have happened. And so I really do believe in a process of looking inward, and not outward, and I think **the Internet has really encouraged a new form of looking outward**.

In the days when one hadn't got the information available, you had to put your raincoat on if it was raining, head off for the bus stop, catch the bus, go to the library. Chances are, when you were halfway down the high street, you meet an old friend. You forget the fact that you were interested in, because actually human beings are more interesting than any fact you might be interested in. And so you end up talking about something completely different, so **you become the beautiful circuitous flow of life**, not this sort of ghastly, linear *thing* that knows where it can get its facts.

So we're destroying ambiguity. Google will systematically destroy the concept of ambiguity if it's allowed to do so, or if people allow it to do so. It already *has* destroyed the sense of ambiguity that any individual is capable of if the first thing he or she does is, "Oh, hang on—,"

that sort of loathsome situation when you're in dialogue with someone and out comes the iPhone or whatever it's called, and they tap on the very thing you're talking about, so then they can say, "Well *actually*, Descartes said [gibberish]," and you're all "Oh, f*ck off! I'm talking about *my understanding*, not a general consensus of understanding."

We are becoming the automatons that we imitate, and I think that's one of the great dangers of digital technology, is the fact that it's on-off, ones and zeros, which is so different to the analog process—I don't diss all digital technology, but if we are going to organize the brain digitally, then I think we are stepping into some *potentially* dangerous ground. I think with the on-off, actually, certainly there is a new *form* of psychopath—I think "sociopath" is a word that is so often used. Well, there is a sort of idea that you can on-off in terms of human interaction, which means that **someone can, with no feelings whatsoever, record a violent act on an iPhone and send it off to someone**. It's simply a violent act on the iPhone, it no longer is a violent act in the street.

▌ VV: It went viral—

■ PR: Yeah. When there was a sort of 9/11

in Britain, where it was 7/7 or something
ridiculous, which was as equally a *set-up,* but
anyway, the main news was not saying, "This
has happened, this is why we think it might
have happened, these are the situations," it was
mainly, "We need your photographs." That's
what they were saying all the time on the news
reports, "Send us your photographs, send us
your comments." It was this democratization of
so-called events.

▌VV: But they catch criminals that way! They
put out a public announcement for "everyone
who was taking footage or photos when this
crime happened, please send them to us," and
they actually have caught people that way.

▌PR: Well, that's irrelevant. What it's also doing
is allowing everyone to become the dispassionate
war documenter. Someone has their leg blown
off—you no longer move to help in a way that
human beings *should,* I believe, interact. One
takes photographs of them instead, people
stand back. **One no longer experiences the
experience, the experience is experienced
via technology.** I was on the Staten Island
Ferry last year, and apart from the commuters
who are simply reading their newspapers,
doing whatever they're doing, *all* of the tourists

were taking pictures of Liberty as they went past Liberty. Not one of them—and I'm not exaggerating—not *one* of them was minus their digital camera, or phone, or whatever they were using—they were all taking pictures. So none of them actually *saw* Liberty at all! All they saw was the weeny little thing on their picture.

The whole idea that one of those persons is once removed from experience, well one is *twice* removed from experience because the first remove is by the idea that one is experiencing an experience—oneself looking at oneself having an experience—and one now has got this extra layer of oneself only *believing* that oneself is looking at oneself having an experience. If one can document oneself looking at oneself having that experience, etc etc, slowly one moves further and further away from (or is it "into"?) the *looking glass*. There might be positive sides to that, there might not be, but that's what I see as happening, which is why I said I wasn't really interested. I can play the devil's advocate and see that **there are possibilities within the Internet on a much more McLuhanesque level** of this sort of massive pool where meanings mix and intermix and become an acknowledgement of the flux. I think in the hands of the Descartian thinker,

then actually it is a very *cruel* medium.

But I have noticed that with young kids, there is a *new* form of ambiguity developing, a *new* form of fluidity because that has been their tool. The logic and the substance of the Enlightenment has died in them—or *is* dying in them, but for someone of my own age and for people of my generation who aren't part of the true revolution, which I think only fairly young kids are a part of, then I think all we can do is manufacture a form of cruelty through that information.

■ VV: Well, **what is cruelty's opposite?** Compassion?

■ PR: Yeah, yeah.

■ VV: Well, for quite a while, I've been interested in the idea of fighting the increasing encroachment of what I call "virtual experience over real experience." I think it's very sad when I see armies of people in the streets walking literally like this [holding hand up in front of face] glued to their phones, not noticing other humans. They're alienated from humans they're sharing the same air molecules with a few feet away. But I don't know, I'm not them—I'm sure they have their own rationales about more or less ignoring the genuine environment and people within a few feet of them.

■ PR: I'm sure they have, and it saddens me that so many otherwise nice cafés are inhabited by people behind screens. They don't have partners in dialogue with them, they have their screens, and so the old bohemian cafés that were places of great chitter-chatter and interaction are now places of silence. I actually find that silence very oppressive. That silence is mirrored on most flights, most train journeys, but not on bus journeys. What one has then is the chitter-chatter of people talking into cell phones rather than talking to the persons next door to them. I think that's a great loss. Whether or not we become therefore unable to relate within the more-human context that we of our generation believe has value, I don't know. Whether there's something authentic growing in its wake, I don't know. I tend to fear for the inauthenticity in the way I was explaining how **I have very little respect for academics because of the source of information for academics, which increasingly becomes the Internet.**

But that *is* countered by the fact that there seems to be a kind of strange level of interactive intelligence in much younger kids, kids who haven't yet got out of their teens who seem to me to be *sparkling* with intelligence. So that

suggests that maybe they *are* able to operate those technologies and *not* be removed or alienated from their immediate surroundings *by* them. Maybe that is happening, maybe their minds are more digital. They're certainly faster, there's no question of that. The speed at which intelligent young people are able to operate their thinking is, I think, quite extraordinary, when I think of how I was when I was that age. And the breadth, also, of their thinking is extraordinary. So it is possible. I don't think it's possible, however, for the Cartesian thinker to operate in that way, because they're bound by the "I," "I am, therefore," and that in itself *corrupts information.*

▌ VV: I used to enjoy reading a whole variety of fiction because it seemed like **I would become someone else and identify with the narrator**, the *omniscient narrator*, and look at the world through their eyes in a book. And of course, what I like about books is that at least *you're* the person imagining what they look like and that some imagination is forced into action by reading a book, as opposed to say, watching a film, where you're just *shown* these things.

■ PR: **I find black-and-white film more engaging because actually you're allowing**

the *imagination* **to create the colors**. If the colors are already there, there's nothing to do. I don't watch movies very much quite simply because there's nothing to do, and increasingly there isn't because there are so few movies that engage in *dialogue*, which seems to me the important theatrical part of any movie. Dialogue engages the mind in understandings and considerations, all the intellectual thought and imaginings. Likewise, a black-and-white movie is leaving you to fill in the colors. That's why I like listening to theater on the radio, because then you're even more engaged in imaginings, you're creating your own landscapes to fit the story, you're imagining how the people look, et cetera, et cetera, so *you* are interactive. And increasingly it seems to me that certainly Hollywood aims to be *non*-interactive, except on an exceedingly cheap, sentimental level. Everything is there and very deliberately designed to create this or that effect in the same way as the advertising world operates: it's quite simply designed to have an effect, not to engage or instruct or to educate. Whereas traditionally, culture, be it pictorial or literary or musical, in some way sought to instruct—not in a sort of "I the Teacher" way, but simply by trying to find new ground, "Well,

here's a possibility," like cartography—maps to other ways of thinking, deliberately or not.

It does seem to me that there was a period of time, which was probably in Britain slightly earlier than here, where that sort of started *not* to be the case. Philosophers are rare, the avant-garde has diminished since when, the seventies? I don't know.

▌ VV: That's when the word "performance art" got invented.

▐ PR: Yeah, yeah.

▌ VV: And "conceptual art," both. As you know, conceptual art involved, as they call it, the "dematerialization" of the art object—**it was possible to be an artist just by pronouncing a sentence, or an idea. You didn't have to make it, that was enough.**

▐ PR: Yeah, yeah.

▌ VV: And **I am a huge fan of course of the old-fashioned "Art of the Insane,"** which then became bourgeois-ified to, I suppose, "Naïve," and then "Outsider Art," a more polite term. But it used to be called "Art of the Insane," back in time, because of what you mentioned before—the psychopath sometimes has a take on so-called reality, or an alternate reality or surreality, and they make it visible to us on

canvas or in drawings…

■ PR: Well, there's no question that post-modernism is the anti-thesis to all of that, yet I would counter that the only *real* cultural opposition that can be given to rampant post-modernism is **romanticism, which is a form of psychopathy and increasingly regarded as a form of psychopathy**. The whole idea of the romantic passions are regarded as being so distasteful in post-modern society, so out of place as to be psychopathic.

■ VV: Well, you know the Surrealists made a big deal starting in the twenties about the notion of "mad love" and about *"chance."* Breton wrote about this in his ground-breaking novel *Nadja*.They also extolled the idea of automatic writing and drawing in the absence of "moral standards," you might say, or "barrier erection."

■ PR: Yeah, well, I think that immorality is quite simply *inability* within the individual—the inability of the individual to encompass the whole. And I think that the concentrating of attitudes, particularly romantic attitudes or sexual attitudes, towards a specific is actually an immorality against a greater life force, against life itself. **Any form of specificity is effectively a heresy against the totality**, against the

absolute, and it's something that we all *do*, in one way or another, but I think when it comes into the sort of *moral* framework, one can *only* create immoral acts out of disengagement from the totality, from the absolute nature of existence. So the tighter the parameters of cultural normality, the greater the act of immorality that will be practiced. There's no question that the "War on Terror"—which is not something specific to the U.S.A., we have exactly the same conditions in Britain currently and most of Western Europe— is simply tightening the parameters of human existence, the definitions of behavior, and what it is doing is creating new forms of immorality. I mean **it's getting close to the thought police of 1984.** Thinking is enough now; the existential position has now become criminalized. So...I'm not quite sure where we came from, what you were saying...

▌ VV: I think there is technology, research projects, aimed at telling what you're thinking from some device, some super-camera—

■ PR: Mm-hmm, Mm-hmm.

▌ VV: I've read about it at; it seems like something to fear. There's that fear word again.

■ PR: I think one only has to fear if one believes in any form of substance, that one represents

some form of substance. For example, thought is a substance, the substance of thought is one's own thought. Now, if one goes back to **metaphor, ambiguity, all of those elements which are much more progressive ways of thought**, that actually is far less vulnerable to any form of invasion in that sense. In other words, if one is incomprehensible within the sort of pragmatic world, then one is in a far safer position. And the fact is that most people prefer—because they *like* the idea of personality and individuality—to imagine that they are on stronger ground by being very strong advocates for whatever it is they choose to believe. They will then decorate that with the cosmetic of appearance to further that, when all the time they're really leading themselves into danger.

I mean, it seems to me that there is no greater absurdity than the Hassidic outfit. From the one hand they fear, which they do, and state that they are by nature *separated*. Then why do they by nature separate themselves so thoroughly and so consistently and so perniciously? And that's a wonderful example of *how victimhood can become a sort of way of proud existence.* It's almost demanding that the past be recreated because that is the condition of the existence. By degrees,

that's what I believe most of us do—all of us do, in fact, in one way or another define our own fate, and we define our fate by believing in the substance that we create and then manufacturing all sorts of goo-gahs and nonsenses around that, from how we look to how we present ourselves. So, **in terms of the thought police, they can only identify a problem if you *have* a thought.**

▮ VV: [laughs]

■ PR: If thought is only the manufacture of, effectively, the ego self, which I believe it is, we only have thoughts to effectively ornament and increase the ego self. The non-ego self has no thought; there's nothing to think about, there really is not. We simply have to think because of the contradiction, the duality, created through the ego self. And that goes right back to the beginning: we are given a name which isn't ours, we are given a cultural, religious, ethnic position which is not ours, so already we're *bedeviled*.

Most people never question it, they never question their name, for example. **One of the great liberating things I did was to change my name** because I gave birth to myself at that point, and that's why I did it. I did *not* want to carry the weight of the father and the weight

of the mother *anymore*, I was tired of doing it, why should I represent them? I didn't represent them, I represent myself—I am my own child. It was a very simple thing to do and it really did have a very liberating effect because I was no longer representing the family Ratter, I was representing my own family of me, myself.

▌VV: Is that why you chose "Penny"? A penny is almost considered of no value in currencies—

◼ PR: Well, I chose Penny actually because my brother used to call me a toilet seat philosopher. He was an academic, Oxbridge academic, who studied philosophy, and he regarded me as a sort of bogseat philosopher. You used to have to pay a penny to go to the toilet, so when I changed my name in "respect" for my brother's view of me as being a sort of sh*t-bad philosopher, I named myself Penny—that is...*was* the origin of Penny, yeah, that it was valueless.

▌VV: And **"Rimbaud" of course is to continually remind you that poetry can exist**—

◼ PR: Yes, yes. Well that's not entirely the reason, and I wouldn't have thought of that reason at the time, but certainly it's a hard act to follow. So it's a great thing to sort of set yourself up that way, and it probably hasn't done me any favors, but I think it's a grand idea to do that: call your-

self "Nature" and see what happens! [laughs] And you can have some big problems along the journey.

■ VV: At least Mr. Rimbaud died sixty years before your birth. It is *so* weird how a corrupted version of it—literally the pronunciation of it is *Ram-bo*—birthed itself in the seventies with Sylvester Stallone.

■ PR: Well, I think it was slightly after I had changed my name—it wasn't very long after I changed my name that R-A-M-B-O turned up. So then when I was on air flights, they would say, "Will Mr. Rimbaud and Jones please press the button," because we were booked in as vegetar-

ians, and then there would be great laughter all around the aeroplane, and suddenly it was another weight to carry, so yeah, you're absolutely right. I've often thought I should have called myself "Enid Blyton" and just have settled for that.

▮ VV: Wait, who's that?

■ PR: She was this sort of *kid story writer supreme* in Britain in the fifties—every kid in my generation, the forties, fifties, and early sixties—read Enid Blyton, and she wrote adventure stories for kids, which actually then became very, very unfashionable, very attacked from the literary world as being sort of…not offering sufficient guidance or whatever—they were a bit politically incorrect for some reason, I can't quite remember what the reason was. But anyway, I *had* thought at one time of changing my name to Penny Blyton in honor of Enid, but I didn't.

▮ VV: Well, I say: **change your name and you change your destiny**.

■ PR: Oh yeah, there's no question. It was quite interesting when I did change it because I had a numerologist friend who did—

▮ VV: Numbers.

■ PR: Yeah. He did a numerological reading on my original name, and on my new name, and actually it was quite shockingly prescriptive—

more about aspirations—because obviously I hadn't had my name for very long at that time, but certainly "Penny" started travelling in a very different direction to where "Jeremy" was travelling. It was the time at which I took the existential leap, and it certainly allowed me to make that leap and live the life that led off with *me,* and I think that Jeremy would have put up quite a degree of resistance, because Jeremy was carrying the weight of the father.

■ ■ ■ ■

The Counter Culture Hour Part 3

❚ VV: Ok, **I propose that now we take things, as much as possible, one hundred percent into the realm of very dark humor**.

■ PR: All right.

❚ VV: That doesn't mean we'll succeed.

■ PR: Is that why we've got the black hat right there?

❚ VV: Yeah, the black hat. I was impressed, by the way, speaking of that black hat. I mean, it's a theory that we pick clothes that actually do reflect that horrible word the "essence" in us. In other words, you could have picked a brown hat,

North Beach, San Francisco

but somehow it wouldn't have worked as well since you tend to wear all black.

■ PR: Well, I'll tell you the origin of my wearing black, which has nothing to with anarchism. I was sitting one day, I was wearing a black shirt—I didn't often wear black shirts but I'd gotten one—and I was sitting stroking a cat, and it was a black cat, and because it was black and my shirt was, too, all I could see of the cat was its eyes, and I really liked that. I just thought of how beautiful it was, and I wanted to be like the cat. **The only way I could be like the cat was to wear all black**. So from then on I wore all

black. There is a tradition, I believe, certainly in Paris, of black shirts representing anarchism, and that wasn't my reason—my reason was 'cuz I wanted to look like a cat.

Anyway. I don't actually think that clothing or things naturally reflect "essence"—one has to have a self-conscious idea to do that—have a self-conscious idea of what "essence" *is*. I think it much more reflects the *theater* of life that one is playing into. That's certainly how I feel, and I have adopted those particular theatrical appearances. About a year or so ago, that [appearance] was much more inclined towards "New York taxi driver," which did incorporate this hat, which a New York taxi driver today wouldn't wear but a New York taxi driver of the 1970s might, because it amused me and I felt like feeling like a New York taxi driver of the seventies. So, it hasn't really got anything to do with essence, but theater I think.

If I was an unaware person, unaware of one's processes, it's certainly likely that those things would happen, in other words, effectively by mistake. I think it in the same way that **makeup is a form of theater**, and it is used extensively in the theater, but also it's used extensively particularly by women, and most of the women I've

asked about makeup say it gives them a sense of theater or a sense of removedness from who they are beneath the...

▌ VV: ...façade...

■ PR: ...mask.

▌ VV: Oh, yes I like that, "the mask."

■ PR: And I think that clothing is much the same; it's the façade that we put over our naked bodies. The essence *is* the naked body, the essence is the naked mind—if there is any essence at all—and all else is theater. So just as ideas are theater, as we've discussed previously, **how one manifests as a physical being—a dressed physical being—is a piece of theater**.

▌ VV: Well, I feel that clothes are what I call "environment," and I've always said "Don't try to change man, change environment"—no, actually Bucky Fuller said that, because he was aiming for some kind of social change, too. He felt that, for example, if you didn't have roads and highways, you would be forced to have a more ecologically-friendly train system in the same way that before the Internet, people would be forced to have a dialogue with each other in person.

That's only part of it, but you just gave me a thought—if everything in the world is theater or could be framed and viewed and experienced as

such, then how is Dial House, which is what I consider one of the great social experiments of the last forty years—how is that framed as theater, because that seems "real" to me. It seems that you're more in touch with real people than many people ever are.

■ PR: Well, I think part of what I had hoped for, or part of the concept of the "open house," was to *do away* with as much of the theater as possible! One does that by saying, "As far as it is possible, this is an *unconditional* situation." By saying that it's unconditional, you're not defining parameters of the theater which people would enter into upon entering the door. **The moment you start creating any form of restriction, then effectively you are creating a stage, a platform, for people to behave in—in other words, with limitations, a *script*.**

There have been a few occasions where theater has overpowered my idea of the unconditional. There have been other personalities that have imposed drama on the situation, and the only way you can disengage drama short of completely ignoring it is to engage in it, and one can only engage in it as a *drama*. We all know the avalanching, snowballing effect of getting involved in drama: we get drawn into it and then we are

no longer ourselves but a part of the drama, and rather than conforming to our own authentic understandings and beliefs, we rather actually start conforming to the understandings and beliefs that are written into that particular drama. This is how **we get psychologically hooked into roles and role-playing instead of *authentically* responding or not responding**.

And that's very pertinent to what we were talking about earlier, the degree to which we move out of the "Before" and into ideas of ourselves, be they Cartesian or Buddhistic. "Life is suffering," etc etc—all these definitions already define the manner in which we are going to behave, in other words, they are conditional, and I would counter that **the only truly unconditional state is the state of "Before"**—in the degree to which one can exist constantly within that state, in other words, within the immortal and infinite state. When I say that we can exist, already I've defined my right to exist within that immortal, infinite state by placing myself into it, but the fact is that I do exist within and without that state and it's only my self-consciousness that prevents me from knowing and from benefiting effectively from the absolute peace and absolute silence of that state.

All perturbation is an act of conscious-ness and imagination. There's no such thing as perturbation; it is an act of imagination and it is an engagement in the drama, and whether that drama is something like 9/11 or a fight in the street is actually irrelevant. It is the manner in which we engage in those dramas and, gener-ally speaking, are negated. Whereas we believe as Cartesian characters that we are empowered, that's what we feel. We feel "better than" be-cause we "are not": we are not the victim, there-fore we are better than the victim. We celebrate the victimhood of others because we imagine that we stand stronger, until we become the vic-tims and then someone else imagines that they stand stronger.

All my life, I've been fascinated by, horrified by, and even enthralled by the Holocaust. I actu-ally became liberated from that fairly recently. I mean I haven't done enough writing about it yet to be entirely articulate, but basically speaking, the sort of thoughts go as such: we are at this place now and it can *only* be this way. There's no other way in which we could have come to now. Everything is absolutely as it must be to main-tain this situation now—which is already fifteen or twenty seconds later! I'm not about to come

in on Descartes' "now" because I've got a lot of argument with our concept of "now" because "now" is as much dependent on the Cartesian individual as any other construct, but what I am saying is *if* there is anything—and let's imagine that there is—then it can only be as it is.

It would be an absolute denigration and a denial of life to engage negatively in the victimhood of the Holocaust. The victims of the Holocaust *allowed*, and this is pragmatic and rational thinking—they allowed this moment to happen. This moment could not have happened if that had not happened, which isn't to say all sorts of other things *might* have happened, but the simple fact is that other things *did not* happen. You know, life got here on everything that's ever happened, and I would actually (but that's another conversation) say that everything that's going to happen determines the position we're in. Now, I think it would be quite simply, for want of a better word, ungracious to engage myself in the victimhood aspect of the Holocaust. What I have to do is celebrate, not in a cruel way, not to confirm the criminal cruelty of the Holocaust, but to **celebrate and to honor those who suffered that we might be here**.

And that is to engage in that absolute sym-

biotic nature of our lives. I think that carries a huge responsibility because if one is going to cease to dismiss the Holocaust as a terrible victimhood and a shocking tragedy and all the other negative things one can bring to it, and if one looks at it more in the sense that *it happened that we might BE,* then suddenly you're embracing life in this massive way. This is a thought that changed my whole worldview from being one of trying to make the best of a bad job to realizing that the job has always been the best, the only way it could be. Out of that, the moment has arrived—anything before that isn't the same "Before" as "before the 'I,'" it's a different "Before," it's the Before of history, which is the scripted, external imaginings that we have.

▌ VV: "Before the script was ever written."

■ PR: Yeah [laughs]. And so I now consider it utterly ungracious to engage in victimhood, or utterly ungracious to engage of the people who leaped from the tower blocks on 9/11 as being some horrible victimhood. They were allowing this moment to happen, and they must be honored with the grace that their gifts were as huge as any other and as minimal as any other that has been made that this might happen. We each are a part of that gift. I think that there's some-

thing very similar to the existential sense of *responsibility* that existentialism inevitably imposes upon those who make that leap. I haven't written about it or thought about it enough, but I feel that these thoughts, particularly about the Holocaust, are an advancement in responsibility from the existential point; it takes a greater responsibility for that which has been or that which we imagine has been, but it at last manages to **embrace history with grace and life rather than with a sense of victimhood**.

▮ VV: Guilt, you mean, guilt and denial.

■ PR: Yes.

▮ VV: I like that. I mean, I kind of like that whole approach toward viewing any what we might call "atrocity" that has ever occurred in any history on any country with "we are here because that happened."

■ PR: I mean it *actually* excited me, that thought, in the same way as when I was able to make the existential leap. Suddenly I knew I was throwing myself into some new territory.

▮ VV: I have to think about that, and we'll have to talk after my subconscious has worked on it. Now you are, of course, as other people would accuse you of being, hyper-verbal...

■ PR: Yeah [laughs].

▎ VV: …or just very conversant in the world of words, which I always call parallel to the so-called *real* world, just as I consider friends to lead *parallel* existences to mine, not identical ones. But I think that having the social experiment Dial House as your "laboratory of life" deals with a lot of non-verbal lessons that the earth can give you, and I suppose to harvest the best of that, you must eventually articulate the various, manifold, complex, and detailed lessons of running an entire farm—building it up, improving it, harvesting the crops, planting the crops—I mean there's a lot of real life, not-high-social-status involved. Nevertheless, some would argue that you have spent thousands of hours learning the lessons from the earth.

▎ PR: Well, I can only describe that as people sometimes accuse me of living a privileged life. I would agree that I have lived a privileged life. I've been privileged by the earth, and I've been privileged by actually doing something that's very, very rare nowadays for Western humankind. **I've lived on the same piece of earth for nearly half a century**, and I can watch every single minute change, from blades of grass to limbs on trees to the actual movement of Earth, which, over fifty years, is quite extensive. I mean

it's only an acre of land, obviously it's surround-
ed by land that I know slightly less because I'm
not involved in its husbandry, but the shape of
it has changed, the colors, all the inflections, the
meanings, the *lessons*. And if there's any lesson
to be learned, it is about the exquisite and un-
avoidable change of the earth, the shapes, why—
and there *will* be a reason—one piece of grass
will go one color and another will go another.

One is actually living in a very stable universe
in that sense, and that stable universe includes
what we call climate change. **People who are
very, very concerned about climate change
tend to live outside the effects of climate
change in the sense that they tend to be more
urban people who are involved in more in-
tellectual processes than they are in actual
discovery.** There are exciting elements about
climate change and "how do we adapt to this,"
and certainly the complete unpredictability of
the climate has been something we have been,
for want of a better word, struggling to come to
terms with at Dial House within the horticultur-
al arena because it's almost impossible to predict
how and when to plant, which has never been
the case before. One makes adjustments, and,
well, that's an exciting challenge. At the same

time, I mean on a more mundane level one attempts to share his or her knowledge because in sharing that knowledge one possibly creates the political atmosphere that is necessary to make any of those large-scale adaptations if they're going to be made. I would probably suggest that they're not going to be made sufficiently to make any real difference. It does, in the end, come down to the fact that **the only real differences can be made by one's own contribution**, or the lack of it, to the living earth.

▮ VV: Within your one acre.

▮ PR: Yes, but for example, one of the things that was **part of the agenda within Crass was the promotion of vegetarianism**. Well, with that one acre of land where we were able to live and practice it as a sort of life form: *vegetarianism magnified, massively*. With the information we handed out, we were able to change the vegetarian movement from being essentially a middle-class, rather *denialist* group of intellectuals into a massive street movement where you could almost *assume* that anyone wearing black and a mohawk was also a vegetarian. Then out of that, you now can buy vegetarian food in just about any supermarket; it created a market, and that market has also expanded as those kids have

grown up from being black-clad and mohawked into working in the media or social services.

Those effects then went on—maybe they're working in hospitals and they'd say, "This diet, it's not very good, why don't you try [vegetarianism]," or in the media and they've said, "No, no, no, why don't we do a film about vegetarianism," etc etc. So, that one acre has produced thousands if not millions of acres of possibility, and that's the *cultural* effect. Now, if we had sought in a cynical and contrived way to achieve that effect, then I would say that we probably would have had no effect whatsoever. The simple fact is we were *living* the truth, and failing some, quite often, within that very truth, [of] the unconditional nature of existence.

And obviously there's a problem there when you say, "Well, if we're living unconditionally, why are we all getting into a van and driving off to London to do a performance? Isn't that a little bit unnatural?" Because certainly prior to that with Exit, our earlier band which was far more radical than Crass, we didn't decide we'd do something, we just *did* it. It was a far more open-field thing on every single level. Everyone could be in it, there wasn't a specific band, there wasn't a specific program, there was absolutely

no reason for doing it except that we did it. So [Exit] was *closer* to the activities that we were involved in in the house than Crass was, which was a much more organized thing—no surprise to me that Crass was the most publicly taken-on thing, because it in some way fitted more into the consensual picture of how you ought to behave: "You're a band and you do this." We were able to subvert that and very, very effectively. We were able to subvert the whole commercial process of the music industry, subvert all the messages of consensual society, from passivism to vegetarianism to feminism, etc etc.

But we were not doing it self-consciously. I mean, we were a group of people living together who realized that **an awful lot of feminist ideology was important to incorporate into our everyday activities**. Well, part of our everyday activities happened to be being a group of musicians, or band members, meeting up in a rehearsal room. So rather than saying "c*nt" as a rude word about something, which was a sort of insult to feminist consciousness, we removed the word. We weren't doing it because we wanted to promote feminism, we were doing it because we wanted to exist and coexist as a body of respectful people.

■ VV: To get rid of all the language of disrespect is what you were trying to do. That's part of an "intention."

■ PR: I'm not sure that that was part of the intention, but you would have to incorporate that within the framework of, "If you're attempting to create an unconditional situation, then you can't be laying conditions down," and ultimately you'd have to go back to everything we've been talking about previously. You would actually all have to be existing in "the Before," which clearly I have yet to find the word for. Although, with the people I'm closest to because we've lived together for so long, I think we are, to quite a large degree, able to exist in that sense of "Beforeness," in other words, all of these conventional ways of establishing and then reestablishing or confirming a relationship have become unnecessary. In more conventional language, we've moved into the realm of *trust,* which has no questions because questions are a way of confinement, a form of confinement.

Sometimes intellectual- and self-questioning is an important confinement because what one's doing is defining what it is that confines him or her so that one is then in the position to remove the confinement. So that's important, but to im-

pose that on someone else is either manipulative or disempowering—it's schematic.

■ VV: I had a thought—your language *confines* your identity and it's your duty to constantly be questioning that and to be skeptical. I love the early Greek skeptics precisely for that reason.

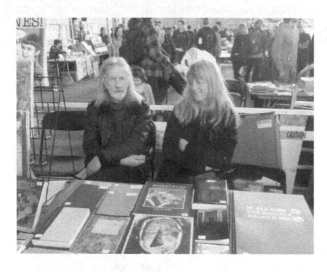

■ PR: Yeah, absolutely. As we mentioned in the Q and A the other night, I very much honor anyone who has at any point in my life been able to *dis*illusion me because there are certain things, certain situations, where I am deluded

into a certain way of thinking, and delusion is very powerful—delusion gives rise to all sorts of matters.

▌VV: Delusion gives birth to more delusion.

■ PR: Yes, it does. So therefore, **anyone who is able to present me with a configuration that destroys an illusion has my honor and respect for life**, which is quite contrary to how most people approach life as people are so very protective of their delusions. **People want to maintain their delusions because they believe that their delusions are who they are**, whereas I now am very aware that my delusions are the things that *prevent* me from being what or who or why or when I am—

▌VV: Or, all the selves that you could be. Well, with that "humor" theme in mind, I'm curious to ask you a few "real life" questions. For instance, do you recall all the incidences in your entire life where you had to deal with either the possibility or the reality of physical violence with another human or humans?

■ PR: Well, there've been very few.

▌VV: Good.

■ PR: Uhm…I believe that that can only occur with some form of complicity on behalf of the so-called victim (we don't need to look at the

victimizer because that is his or her intent). Now the argument, generally speaking, is that the victim has no intent within the situation under which they have become victimized, but I would argue that that's not true. I believe that any situation is the sum total of all the components, which is *not* to argue that a woman who is raped is complicit in the conventional sense, but it *is* to argue that there is some *flaw* in her imaginings (or his imaginings), and that that is the complicity—the flaw is the complicity.

Now we can armor ourselves against that, which *might* protect us, or we can become invisible within that, which totally protects us. An invisibility is nakedness. It doesn't necessarily mean invisibility in the physical sense, I mean it is quite simply nakedness. Nakedness is of heart, soul, body, and mind because that cannot be abused, it is not possible. So one has to then say, "Well, **victimhood is an identity, a *taken* identity**." I remember seeing a movie where a group of a dozen rapists were asked to look at a film of people walking along the street and to identify "victims." And the frightening thing, if you want to call if frightening, or the illuminating thing, if you want to call it illuminating, was that they, probably about ninety percent

of them, were in agreement. They individually watched the film and said "that one," "that one," "that one," and it was the same person!

Now that suggests that there's some program going on there. I've had so many violent arguments about this subject over the years because this isn't new thinking, it's very old and established, but I believe that the first thing to study within any situation of abuse, and actually within any human interaction of any form whatsoever, is one's *complicity* within that situation, from the situation of breaking a heart to breaking a cup. Why did I break that cup?

I don't believe in accident. There is a complicity and an agreement being made to allow any of these things to happen—and that's to be acting within the symbiosis, that's exactly the sort of physical *now* manifestation of that thesis I was putting forward about the Holocaust of acknowledging that **things must happen for this moment to arrive**.

▌VV: Wait, let's get real. I'm going to…

▬ PR: [laughs] I'm going to punch you!

▌VV: [laughs] I want you to describe this incident that happened when you were very young. You were in a dormitory, and this big guy came in with a huge flashlight and you ended up being

struck quite severely on the head.

■ PR: Well, I had been expelled from one public school in England for malpractice, which was nothing more than smoking cigarettes in a coffee bar, which in those days was sort of like snorting heroin in a coffee bar, anyway, and I moved to a boarding school in Wales.

▌VV: Was that more posh, the boarding school? Here they're considered more "upper-class"—

■ PR: No, where I'd been expelled from was *also* a boarding school, it's just that I wasn't a boarder because I was a local. So, I moved to the boarding school and my first night at the boarding school I'd been given my dormitory, which is a shared room you have, in my case with two other boarders. **I was sitting at my desk looking out of the window across the Welsh landscape**, looking at the mountains, feeling a little bit upset that I'd been taken away from my family (eventually I realized that that was one of the greatest gifts my family could have given me—at such a young age, I no longer had my mum and dad peering down my bloody neck).

▌VV: What, sixteen or so?

■ PR: No, I was fourteen or thirteen, maybe. Anyway, on the first evening I was sitting, peering out across the Welsh landscape and I heard

this noise of people behind me, and one very big boy with a very big rubber torch was standing there and he had his accolades behind him, which are all his young supporters, and he basically said, "What's your name?" So I told him my name, and he said, "Well, what do you do?" or, "What are you?" Something like that, and I thought probably the most inoffensive thing I could possibly say to get him off my back is, "I'm a poet." So I said I was a poet and immediately he swung the large rubber torch through the air and whacked me on the skull with it.

▌VV: And you didn't see it coming—you did not anticipate that?

■ PR: I anticipated something or other. I thought I could possibly deal with it by being straight forward, and I *was* being straightforward—I did used to write poetry in those days—but I really did think that that would be enough for him to realize I wasn't a threat. But it *wasn't,* because actually *whatever* I'd have said (and I don't like repeating myself but I will)… if I'd said, "I'm a Rottweiler," then he'd have done just the same. It wouldn't have made any difference. *Whatever* I'd have said, he was gonna turn around to the kids and say, "We don't like poets, *do we*," or "We don't like Rottweilers, *do we*" or "We don't like

conservatives," or whatever I'd come up with—would've made no difference. I was gonna get a whacking because he was the kingpin, he was the bully of the school. The end of the story is that over time, in the one year that I lasted there, and I wasn't actually expelled from that school, I was asked not to come back, or my parents were asked not to send me back, I did during that year form a, if you like, a...

▌VV: ...a revenge?

■ PR: No, I can't remember what you call it when you create your own militia.

▌VV: Oh, you formed a gang.

■ PR: Yeah, **we formed a gang and basically we went around eradicating bullying**. In those days, senior members of the school were permitted to cane, or to beat, younger members for any violation they chose to make up. Bullying in those types of schools is pretty common and extensive and accepted. I doubt very much that it's particularly changed. Violence is very much a part of the public school education, and sex as well of course. So, yeah, I made it a mission that we would eliminate that and we did it through our own means.

▌VV: Through violence.

■ PR: Acts of violence, yeah.

■ VV: Now, is that the only violent encounter you've ever had in your long life that actually ended in physicality of action?

■ PR: I've, on two occasions, responded with what appears to have been violence. My mother was dying from brain cancer and she used to have terrible seizures. She was becoming increasingly less lucid, and on one occasion she became hysterical and I just really did not know what to do. I didn't hit her out of cruelty, I hit her in the hope that the strike would be sufficient to calm her, or stop her because I was frightened that she was going to "hysteria herself" into another seizure. Seizures are horrible things to deal with. So I whacked her, and that was, by any standard, an act of violence, but it did actually work. It was horrible to do and I felt awful doing it, but I do believe that it was the only thing to do.

■ VV: **Preventive violence to deter perhaps even worse consequences—**

■ PR: And I think on two other occasions I've done the same to deal with hysteria. Certainly my experience with severe hysteria is that if you simply try to hold someone down, you're actually adding to the hysteria, almost magnifying it because in the restriction, it becomes even more of a gratifying state for the hysteric, if you

understand what I mean, because now they're really feeling all of the massive contortions of the body. Apart from that, I've lived a life that is violence-free.

■ VV: Well, that does seem more consistent with

what I imagined your philosophy of life, i.e., your outlook on life, might countenance.

■ PR: I think violence on a domestic level is the result of trying to impose needs that are not being satisfied. I mean, I don't have any needs in that sense, or if I *do* have needs I at least recognize they're my needs and therefore I have

no right whatsoever to *impose* them, and I think that **argument is the worst way of trying to solve any problem**.

▮ VV: Even though you love to argue?

▮ PR: I don't love to argue, I love to *discuss*.

▮ VV: "Discuss," *pardon moi*.

▮ PR: My discussions can become more and more articulate and more and more passionate the more I'm interested in a particular idea, and I am sometimes accused of being contentious, but I'm only contentious because I want to understand what someone's saying.

▮ VV: And you want to go further and deeper.

▮ PR: Yes, and I hope I have learned over the years to be more gentle, not to allow my voice to get "uppy." I mean, it's excitement. I get excited by my ideas so my voice tends to rise and that can too easily be mistaken for aggression, but I certainly do not feel it. Simply, I become passionate about the possibility of an idea and get over-excited.

▮ VV: Yeah, because you're pro-passion, anyway, as we think that society has a way of repressing really extreme passion in us. I want to try and switch to the topic of **all the ways you have historically inspired yourself to write poetry or draw or find a solution on the farm, which**

I consider an art project. In other words, I think there is no separation between art and life in your universe.

■ PR: No, there isn't.

▌ VV: And that's certainly my goal, too. Every conversation, you could argue, is a work of art or a work in progress. With poetry, a lot of people, like me, have tried to write poems and have been extremely inhibited and written awful stuff that Burroughs described as what you wanna rip up into tiny pieces of paper and flush down the toilet after you read it the next morning. So you, I mean I hate to talk "process" 'cuz I hate that word, but you have generated a lot of poetry, and how the heck did it all happen? Do you carry a notebook all the time? Are there notebooks scattered all over your home?

■ PR: I do carry a notebook, yep, and quite often I don't note stuff because I believe that if it's worthwhile it's going to reappear, that it'll come back again.

▌ VV: I'm scared of that one.

■ PR: Well, I'm not.

▌ VV: I think **every thought flies and ideas are like birds: if you don't write them down immediately they may never come back to you again**.

■ PR: Well, in that case, they aren't valuable enough to *want* to come back, that's how I see it.

❙ VV: [laughs]

■ PR: I'm quite casual about my note-booking in that sense. Also, I don't give any importance to it. **The major point with poetry, and I think the major point with music, certainly with jazz, is that the more YOU *get out of the way*, the more it happens.** The poet can't be in the way of his or her work. You cannot be a poet *and* write poetry—you can only *write* poetry. The moment you become a poet and are actually defining a situation that can only *be realized*, the very thing it cannot be realized by is through one's self. Poetry *happens.* I can write an essay, be at it for nights, intellectualize at it for nights—but **poetry is something that creates itself**. It happens by its own demand. I mean, I cannot write poetry on demand, there's no way at all I can do that. I might say to myself, "I'd like to write a poem about such and such," but I won't be able to until the poem writes itself.

❙ VV: That's what I call "channeling."

■ PR: Yes, well I think it is channeling of a sort. It's channeling some universal thing, or life, or whatever, I don't know, and I don't particularly care [to be] specific, and on two occasions I *have*

been specific—on one occasion, I wrote a play that was an extension of Dylan Thomas' *Under Milk Wood,* and it did seem to me that all the language that came out was like *his.* Likewise, I wrote an update on Ginsberg's *Howl,* and again it seemed like I was writing in a language that isn't how I always write. It wasn't a self-conscious thing, it just happened that way. Certainly in my latest book of poetry, well, it's not really poetry, it's just words, *Third Street Blockade,* which I wrote last year in New York, I didn't consciously *do* anything. On that occasion, I carried a notebook all the time, was just writing all the time, literally, and the result was a hundred-and-eighty-page reel of words, which I didn't edit. I didn't attempt to put anything into it or take anything out, it's just "that's it, that's how it is."

▎ VV: A rough draft.

■ PR: Yeah, because that's where it belonged. An awful lot of its language is very, very not-English, it's American, and obviously because I was talking to Americans and going into American cafés and having to ask for coffee and whatever in the way you have to ask for it in America. It's a different way of speaking. It interests me the degree to which the *Third Street Blockade* was

written in American and not in English. There are bits of English in it, but there are also great chunks of American in it, and they are very different languages.

▎VV: What about when you're drawing? I read that **you produced a book of drawings because you couldn't write**, or wouldn't write—was it that you couldn't or wouldn't?

■ PR: Well, there was a year where words just didn't happen. They just weren't there. I mean I could still talk, but I didn't even do an awful lot of that. I certainly pretty much stopped philosophizing during that year, because philosophy is the science of thinking. It isn't just throwing

silly ideas into the world, imagining that they might work—it's trying to ask "How does this work?" which is why I'm interested in modern physics, because in some instances it can give weight to a philosophical point. Sorry, what was the...?

■ VV: What was the catalyst for producing a book of sixty-two drawings?

■ PR: Yes, as I was saying, I didn't have any words there, and without words, in a strange way there wasn't anything. There was the bread to make, and the things to do—well, those things take however long they take—and then

there was empty space. **Someone had given me a sketchbook** which I'd just stuck into my shelves, where it remained untouched for a good few years. I pulled it out and looked at a blank sheet and then picked up a pencil and drew a line, then did another line. It wasn't trying to *say* anything, it was just lines, it was doodling.

▌VV: You mean lines appeared—

▐ PR: Well, effectively—I wasn't trying to do anything. I wasn't trying to draw a picture of anything, I certainly wasn't trying to explain anything. I was simply sitting there filling time. Something took me back to when I was primarily a visual artist, where I'd spend hours and hours

and hours painting and drawing, not really "thinking" in the word sense of the word. **I was drawn back into that world of silence.** The work is non-figurative. It is non-narrative. It was really nothing but doodling, and very articulate doodling in the sense that I am a trained artist. I know how to control light and dark, shape and form. I just did it. Day in, day out. I was never without my sketchbook wherever I went. If I went on holiday, I didn't sunbathe, I just sat and drew. In a year, I'd filled up this book with sixty-two drawings and the funny thing was that in about two drawings before the end, a word ap-

peared, and it was something like "just," I can't remember quite. Actually, in the first drawing in the book there's a word or two that somehow found their ways into it. And then towards the end, firstly one word, and then in the last drawing, there's a few words including what was at first "renaissance drawings," and then I thought, "Well, these are renaissance drawings really, and there's sixty-two of them," so I put "sixty-two" in self-consciously and closed the book, and that was that.

I had no intention of doing anything at all with the book. I used to show it to friends and

say, "Those are my drawings," but the idea of exhibiting or trying to do anything with them didn't enter the equation. It entered the equation a few years back when we still owed money on the house, and when it got to the point where it was £62,000, it rang bells and took me back to the drawing book. On a sort of fantasy level, I looked at it and thought, "If I sold each of these for a thousand quid"—because the art world can be that crazy—"then we could pay it all off." Well, since that time, the work is on show currently in New York at the Boo Hooray gallery, and we owe considerably less. Whatever we make or are able to make by selling those works,

which have now been torn out of the sketchbook and put into frames, goes towards paying the house. I've honored the idea that those drawings should be used for paying the house in the same way that I sold my bass drum skin from Crass days, which had the Crass symbol on it, for a large amount of money so that we could buy the exact microphone that we needed, a Neumann, a very expensive one, for the studio that we'd just put together. So, I'll make those efforts to make things into some sort of commodity *if* the result is creative, productive, and can be shared by people in the common fold.

■ VV: You know, we're coming to the end of this segment, and I was really hoping to condense all the inspiration you could give humans on how to be creative, how to be independent, how to avoid day jobs and working for others, not only to manifest all the potentials that you were born with but even discover potentials you didn't know you had.

■ PR: I've got an immediate answer for that. **Look only to yourself—the self you will never know**. And I'll repeat that: Look only to yourself—the self you will never know. Then you will be in the position to do all of the things that you just wanted me to give a picture on.

That would be the *absolute* message.

■ ■ ■

Panel with Gee Vaucher & Penny Rimbaud

On March 17, 2013, The Emerald Tablet in San Francisco hosted an event for Penny and Gee Vaucher, which included poetry performance by Penny, a screening of Gee's film: "Angel," an "art on the walls" pop-up show for Gee Vaucher, and this panel discussion moderated by V. Vale.

■ VV: So I hope that everyone in the room is still slightly under the spell and mesmerized by Gee's film "Angel." I want you to just tell us how you came to make it and what does it mean? It's kind of hypnotic in the right frame of mind—

■ ■ Gee Vaucher: Well, it's actually of my great-niece, Angel—that's her name—and just as you watch children grow, you can really see obviously their faces change a lot. In England, you go from eleven years old from a juniors' school, up into the seniors' where you're mixed with all the big kids. I've seen it several times: the face changes very quickly. It suddenly grows up, and they get street-wise and all the rest of it. I thought I'd capture it *before* that happened.

I had an idea for a film, and I started shooting it like you saw, but when I finished it, it definitely was saying something that I hadn't thought of. For me, it's really about the joys and fears of a child, the terrors that you can go through, and the exquisite joy of life. It's as simple as that, really. But somebody else got something very different, which I love: [Robert Hass] "Privilege of Being." And I found that quite interesting. Much more intense than I…

I mean, there's nothing really grand about [my film]. I do love the way it's very mesmerizing, the way the face changes so much. We look at each other's faces every day, and that's what's

happening. Your expressions are extreme and subtle, how they go *through,* and we don't see it very often. It's too quick. Or we don't look at each other for long. I get very tense when I watch the film, I must say—I stop breathing and have to remind myself to breathe. And to sit through it is quite a haul; I understand that. But nobody walked out—I was quite shocked! [laughter]

Thank you for that. I mean, it's hard to know how hard it is for people just to sit through nearly an hour of watching that face. Hopefully, you all got something from it—

▮ VV: Well, you seem to *slow down time.* It seems like time goes by so fast now, and it was taken to some absurd apogee by MTV-editing where you have a cut every tenth-of-a-second or something. And it's an *antidote* to that, certainly. In fact, I think **time is going by so fast that we need to slow life down.** That's *my* lesson I deduced from your film—not the only one. How did you set it up? It looks professionally lit and all that. What was the situation?

▮▮ GV: It was in the studio, and I just sat her down and shot the film.

▮ VV: But it's slow motion, right?

▮▮ GV: Yes, I slowed it right down. She can't sit still for an hour [laughter]. She'd have *died.*

And you can actually see, towards the end of the film—'cuz we shot it for about an hour—you can see at the end of the film she's starting to fall asleep—I quite *like* that. But the cuts are very subtle, yes.

▮ VV: I'll say. And what about the sound? Was that kind of partly chance? How did that happen?

▮▮ GV: Some of the sound is ambient, so I just left that. As you slow the film down, the tone goes right down. I found some sound that seemed to describe what I was trying to do—

▮ VV: Wait, *where* did you find this sound?

▮▮ GV: I had some very old BBC sound recordings. So I nicked them.

◗ Jennifer: We won't tell [laughter].

▮ VV: Great. So not only do you do visual appropriations in your collages, you do *sonic* ones in your movie soundtracks. How long did it take to edit? [microphone feedback]

◗ Woman in audience: Now *that's* a found sound! [laughter and clapping]

▮▮ GV: It took over a few weeks.

▮ VV: Of pain or pleasure, or both?

▮▮ GV: Uh, a lot of obstacles because I didn't know how to use the program. [laughter] So it was a matter of hit-and-miss. But I managed. I

got some help in the end to get it off the machine. It could have taken a much shorter time, but I'm not very good at the technical side.

▌ VV: Apparently you don't have to be—look at what the film is—

▌▌ GV: That's the *easy* part: to make it. But how do you package it up and get it off the computer? That's not my field. But there's a way.

▌ VV: Okay, you have friends in competent places. So... are you happy with the film?

▌▌ GV: Yes, I'm very happy with it. I think it's one of my best— [laughs]

▌ VV: Wait a minute—you've made a bunch of films?

▌▌ GV: Well, a few. Not a lot. Anyway, maybe we should open it up to the audience—

▌ VV: Wait, I want to give Penny a small minute in the sun. [laughter]

▌▌ GV: That's *fine*.

▌ VV: Penny, this is probably such a stupid question on one level, but it's probably one you get asked a lot. *What are you?* [laughter] A poet? A drummer? What?

■ PR: Um, I really have that problem myself. Seriously. I don't know, and I don't frankly care. **I'm whatever I'm *doing* at any given point.** The only problem with that is that first thing

in the morning when I wake up, I genuinely don't know *who* or *what* I am. It takes quite a large amount of caffeine and nicotine to sort of introduce me to some sort of program, which is something I sought for all my life. It's something I wanted. Now that it's arrived, I find it actually quite difficult to create an entire *raison d'être* every morning. It's tiresome! [laughter]

There aren't any patterns to hang onto. I mean, if you've decided you're a *something,* then it's easy: you already know what clothes to wear. And increasingly, I tend not to get out of my bedclothes until quite late in the afternoon, and finally I might have arrived at some sort of *decision.* So that's the sort of *short* answer. The long one could take a...

▌ VV: Wait a minute. Let's pretend you're a drummer. Does anyone ever ask you, "Are you a drummer?"

▬ PR: Well, they're not liable to, really. People often might say, "*Were* you the drummer of Crass?" And I was, but that doesn't make me a drummer now. It simply means that that's what I *was* doing. I don't attempt to and I'm not interested in taking *elements* of myself to represent a Self.

▮▮ GV: It's not important, is it?

■ PR: No. And I don't regard the skills I have in one field as being any more or less important than the skills I might have in another. I was up in Connecticut last year in the Physics Department at the University of New Haven working with a professor of physics there, just mucking about with ideas. And academics like to know precisely *what* you are. I was just saying I was a bread-maker because that way they got right off my back immediately. That was an honest answer, because I *am*. I'm a very good bread-maker, and actually, bread-making is better: **if I make bread, everyone likes it. If I do poetry, a *few* people like it.** [laughter] So it's sort of a pretty good bet.

But that didn't go down too well with the academics because they really want something very defined. I mean, what the f*ck are any of us? And actually, who the f*ck cares, in truth? Unless they want to say: "I want this bit, not that bit." But I would prefer to give people the problem of having to deal with the *whole mess of me* rather than the little bit they want of me. That way, you get fewer friends, but they're very good friends. So that's...

■ VV: Come on, I know you're a drummer—

■ PR: I had never regarded myself as a

drummer, and I never actually took any interest in *being* a drummer. I simply picked up sticks and whacked things, which is what kids do. I mean, kids are all sorts of things in the day, aren't they? They're 1,001 things. They believe all of them wonderfully. They pick up sticks and they're warriors. If I were to start being poetic about drumming, there's a great beauty about the primal engagement with skin.

When I was drumming initially when I was a kid, and then with another big outfit called Exit (a band we had way before Crass), I always used skins. Now, largely vegan and vegetarian, it would probably be a tasteless decision, although I still use skins on hand drums. But they were exquisitely earthy-to-play skins. You were honoring the very *Being* that had produced that material. To play plastic, which I played for Crass—because that would last and it creates that Rock 'n' Roll sound, which I don't even like anyway—it's no longer drumming in the primal, earth-moving sense. It's feeding the human senses what they already want and what they need or *believe* they need.

What interests me are the connections that are drawn through the drum back to Earth, not the connections that are made out

into a concert hall. So I was drumming to the Earth and celebrating the Earth, I hope, in my drumming. And I was very involved in that— very deeply involved in it, but not as a drummer.
▌VV: Yeah, but I've read that a number of jazz drummers pay attention to what you've done: on certain records. What do you say to that?
▇ PR: Jazz is one of the few music forms that

Emerald Tablet performance

constantly attempts to return to primal energies. [Coltrane's] *A Love Supreme,* which I often quote because that to me is one of the great primal statements in modern art in the same way as Pollock's paintings haven't really been superseded, is touching the depth of human soul, which is not human soul but *pre-human.*

In other words, engaging with the Before (and not the After of life, where we know what we can do and to do it is so tedious and uncreative). **To attempt to find that which is doing the doing, which isn't us**... there's some force at work, which is making us, helping us, breathe. It is breath. And nothing, to be honest, interests me about any particular externalized, *out-there* expression.

I'm simply interested in the Before and allowing the Before to get on with the job. Then *perhaps* one is making some form of primal, universal, or even *astral* pronouncements. I mean, Laing—R.D. Laing is someone I happen to greatly admire, the existentialist philosopher—talked about **trying to regain the primal.** I only have one argument with him in that I would be more interested in regaining the *astral.* And I believe actually it's possible, which is why I was in the physics department at [University of New Haven].

Increasingly, quantum is coming up with all of these answers, which traditionally have been the domain of the mystics. The physicists have armed the mystics with fact, and that's great. The mystics have been saying the same and have been pretty exact throughout all time...in

pre-Greek philosophy.

▶ Woman in the audience: Imagine if you had told [the academics] you were a mystic: "You got a Ph.D. in *that?*"

■ PR: It's funny, that. I became a mystic because my father, who is a very "external"—he lived in what he called the "real world," which is where people killed each other and did things like that, which I never liked. I didn't quite understand that, especially being a child of the War. And I'd done some painting when I was at art school, which he loathed. And he said, "You're a bit of a mystic, aren't you?" And he meant it *really unpleasantly.*

To him, mysticism was some sort of foul, abstract thing that existed way beyond anything that was worthy of consideration. And I hadn't really heard the word before, so I went to the library and came up with Evelyn Underhill's book on *Mysticism,* which remains to this day one of the great bibles on mysticism. I suddenly started recognizing all sorts of things that made sense. It's quite strange that the very man who was throwing this criticism at me actually handed me something on a golden plate. That was the beginning of my maturity—I think in my early 20s...

▌ VV: Most people wouldn't put Crass and mysticism in the same sentence—

■ PR: Well, I actually disagree with you.

▌▌ GV: Disagree, yeah.

▌ VV: Oh, I like disagreement—bring it on!

■ PR: I think one of the reasons (and I don't think it's vain to say) we were strangely unique in the genre is because a) we meant what we said, and b) what we said came from a much deeper force than it appeared to have. If you look at some of the work of Gee's, which was the Crass work, particularly *The Feeding of the 5000*, although it shows all the deprivations, the horrors, etc, of that era (which was the late seventies), at the same time it projects through its love and its care, through its precision, through its beauty, *something else*. I believe that's where the [mysticism] connection was. I can hear it myself when I listen to our own work and compare it to the other work that is considered to be of the same genre. Well, it's completely different because actually there's a quality of *search* in everything we did. I've tried to push the barriers and not conform to the definitions of a genre. And inevitably, we created a genre that became imitated and diluted in the same way that someone like Pollock created a genre

that became increasingly tedious. Everyone was throwing the paint around in a way that denigrated the force, which ultimately can't be denigrated; it remains powerful and will remain so throughout time. All the rest of the sh*t and

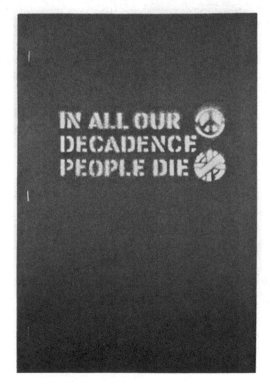

detritus just disappears *en route.*

For example, I wrote a piece called *Reality Asylum* when we first started the band, which was an extreme criticism of the Christian Church, not necessarily of Christ himself, whom I don't think was the greatest of the prophets by any means, and he certainly was not a philosopher. But it was a vicious attack on Christianity. Apart from a few sort of threats from, for example, the Sicilian Brotherhood with the one classic "you'd-better-start-behaving-or-you're-going-to-be-in-trouble" sort of sh*t, the main reaction was from Christians who wrote, "Thank you for helping me realize and understand and look deeper into my faith." I don't happen to buy into that particular form of faith, but I certainly buy into the idea that people can be inspired to study their own beliefs and find out what they want to take or throw away from that.

That's the value of all art: it challenges, or should challenge, one's preconceived notions and undermines them. **I like to be disillusioned.** The people I most love in my life are those who've had the courage to disillusion me. **Why should I want to live with illusion?** If anyone can come along and say, "That's nonsense. That's an absurdity," and actually convince

me, they'd get my Medal of Honor. I don't like to be complimented, particularly. That doesn't help me very much. I believe I do the very best I can, and anyone who comes along and says, "Actually, that's just not good enough"—well, great! Thank you! I'll try a bit harder. Anyway, I'm overpowering. You go.

▌ VV: Well, you did remind me of Marilyn Monroe—I know, what a connection!—who said, "I prefer illusion to reality." But look what end she came to. But she did make *The Misfits*, which is one of my favorite films of all time. Anyway, to bring it back to Crass…

▌▐ GV: Do we have to?!

▌ VV: Oh, sorry.

▌▐ GV: Jesus, it's thirty years ago. God.

▌ VV: Well, we Americans have very little firsthand exposure to your *presence,* so we exposed ourselves first to your *records.* It was a really great experience to listen to the recordings and be able to lose yourself in those copious liner notes, which I loved. You revolutionized a *format,* way beyond any corporate record label packaging. And you did that all by hand, I hear, in some sweatshop factory production line. So Gee, it took a hell of a lot of solitude to create all your art. It can be kind of painful, that

LOVE
IS ALL
OR
LOVE IS
NOT AT ALL

solitude—or maybe it's not?

■■ GV: Nope. It's *not* solitude, is it? You're with *yourself* so it can't be solitude, can it? **I'm quite happy with my own company.** I mean, yes, you're on your own. **It's like anybody creating anything: it starts with yourself.** It may come together with another person or group, but the initial spark is very much on your own. But it's not a lonely thing, it's just something that— you can let your hand start moving on its own

without any interruptions or demands.

■ PR: I'd sort of come in there on this sort of level of deconstruction. This goes back to really honoring people who can disillusion me because basically each disillusionment is a coming together. It's a drawing closer to the universal factor that keeps us all here, that is this moment. So with any form of throwing away, any form of removal—I don't believe art is art if it actually creates definable personalities— it's failed. When Damien Hirst is a greater personality than his art, then his art ceases to exist. That is very much the sort of society we live in, **The Society of the Celebrity**. And that dishonors all the principles of life. It's entirely about *presentation* and utterly lacking in content. But even content in itself is a part of that culture in the sense that it's proof of being. Well, we don't *need* a proof of being. We are all exceptional and unique in our own beautiful way. That might not be in ways we can understand in ourselves or others can understand, but that's irrelevant. I might be sort of critical in that *America* poem I wrote, but if I had a chance to sit with George Bush, I would *talk* with him. I wouldn't be critical and attack the guy; I'd want to know and understand and

respect the fact that here's someone who's trying his best [someone snickers].

I believe that. I believe everyone's trying their best, and their best might be by my terms and my values f*cking rubbish, but it's no help to walk to someone with that in your mind. To walk to someone with love and honor and to respect that is the person they are, like it or not, is the beginning of warmth. It's the *only* way. Certainly in the days of Crass I was very active on a critical and confrontational level. I now see that that was basically a mistake… a mistake often made by people who are not fully aware of their own possibility. It's a half-person trying to fill in the gap. Rather than looking *inside,* we all tend to look outside in those sorts of situations.

Increasingly, it is only by acceptance, engagement, encompassment, embrace, that the things we call the problems of the world would cease to be the problems. **We are part of the problem as long as we define it as a problem**. We have to reach beyond that. That can take huge efforts of heart and soul. The heart does belong to us. I don't believe the soul does. I might make that point.

The 20th century proved that confrontation gets no one anywhere. It simply constantly

recreates itself. I would dread to think that is the future for the 21st century. All the indications are that it might be, but that's because we allow it to be. And we allow it to be because we embrace those forms of activity—in other words, *confrontation*. We have to find a way around that. And it's not going to be through foul, ill-considered criticism. We don't know. We know nothing but our own heart, and that's where we should engage. And the funny thing is, when we're doing that, we become lovers in the true sense of the word, not in the physical sense. And I believe that profoundly. And it works. I'll not say anything more than that.

■ VV: There's a quote: **"Only the lover is truly aware of the beautiful."** I forgot which poet said that—maybe *you* remember. In fact, you are a poet. That's what you really are, right? Admit it. Talk about being a poet— [laughter]

■ PR: Well, I think I can honestly say that I am not a poet in the same way that I imagine Pollock wasn't a painter. The poems that I have written have been written *before* me. I don't think, "Oh, I'll write a poem." I'm not able to do that. They *happen*. The *essays* I write are certainly considered, and they're intellectual: I'll have an idea, and I'll spend weeks developing

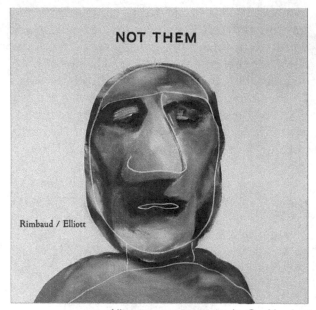

NOT THEM

Rimbaud / Elliott

Album cover art painting by Gee Vaucher

the idea. But **poetry comes from nowhere. It simply manufactures itself.** All I have to do is wiggle my hand around and it comes out. If I start trying to intervene, then it is rubbish. If I start trying to make something clever, I can see immediately it's ugly and clumsy and has no poetic beauty...

I remember once I had been working seven

years on a novel, and that was all I was doing: writing a novel. That does involve intellectual intervention, a lot of editing and f*cking about… (But poetry comes from the Before, or it isn't poetry, mind you.) Anyway, at the end of that, I had this idea of writing about what happened to Llareggub, in *Under Milk Wood*, Dylan Thomas's beautiful play about a Welsh village. **I started writing it, and it wrote itself.** And it wrote itself in the tongue of Dylan Thomas. It had all the sort of strange idiosyncracies that he had, everything, and I really wasn't conscious of doing it. And I wrote it in a week-and-a-half. It had taken me seven years just to finish a novel.

Poems take me a lifetime and a second. They're just there. And I don't really remember doing them… Except for things like "Oh America," which was fabricated, "Prayer" certainly wasn't. "Oh America" had a *purpose*. It was a response to what she had done. It was a political point, which I don't write generally.

But poetry comes from the Before. To *claim* it, is a sort of heresy against the very beauty of poetry. It'd be like saying, "I'm a landscape artist, and I own the landscape." Maybe it isn't like saying that. But you can't claim your own work if you're a poet because it comes from

something before you. Jeremy Ratter, which is my original name, or Penny Rimbaud, has no right whatsoever to claim what comes through Jeremy Ratter or Penny Rimbaud onto paper because it's come from nowhere. It's come from the Before.

■ ■ GV: It's like any creativity, really.

At Emerald Tablet with drummer, Emily Rose & other friends & fans

■ PR: Yeah. Well, not any, but a lot.

■ ■ GV: Yes, but I mean it's like any art or creativity that stands the test of time, if you like. There's something timeless because it's come

from that thing that's—

▶ Woman: Outside space-time. [laughs]

▮▮ GV: It's something you've not manufactured; it's just there. I mean, if you're a painter or a writer, a cake maker or a musician, whatever —it just happens. It just is there. And if it's your experience, if it's your length of life, it's an *immediate* thing. The minute you start tampering and start trying to make it do something—as Penn says—*clever,* then it fails. It's very hard to get that timing, to allow it just to do that. You are the *medium.* I don't mean that in a sort of… It's just having that courage to go to the edge and just fly, because you will. You won't even know what it is you're flying *with,* but somehow it works. You've actually managed to get out of *here* something out *there,* whether it's a word or an image or a piece of music.

I can't re-see it at first; I have to leave it for a day or a week. Then I might walk back and have a look. If it doesn't do anything to me, I know it has nothing. But **sometimes I walk in and go, "Wow, who did that?"** [laughter] It's really funny, and that's when I know it's said what I wanted it to say, even though I didn't know what I was going to try to say. I find that very exciting—really exciting.

■ PR: It's the difference between *verbing* and *nouning*. Verbing is really what we are, and nouning is what we'd like to be in this sort of consensual outside world, which goes back to what we were saying right at the beginning. Verbing is accepting the verbness of oneself and just allowing it to be the verbness of Self. Nouning is saying, "Well, I'm a something or other." Well, who's the "I" that's suddenly jumping on top of the verb? I mean, these sound like metaphysics, but they're not. They're actually profound truths.

Who the hell is Descartes' "I"? "I think, therefore I am"—what a ludicrous thing! The assumption in that, the presumption, is just absurd. That actually, more than any single statement in philosophy, explains the 20th century. I mean, it was the philosophy of the Enlightenment. The entire development of the Industrial Revolution, of the machinery of war, goes back to, "I think, therefore I am." I mean, it's a pretty *profoundly crap* piece of philosophy.

Yet it still governs—despite Einstein, despite relativity, despite modern quantum, and that is just profoundly disturbing. It's over a hundred years since Einstein broke, quite categorically, "I think, therefore I am." This wasn't actually

material anymore. And have we looked? No, we don't look. Actually understanding that *we're not* within that framework is a f*cking frightening thought. I have to say, having done it and come out the other side (I *believe* I've come out the other side!), that to come out the other side without all the signifiers, all the material, all the rubbish of pain and suffering, all those things that the material world carries, is an *absolute joy*.

It's something I wish I could give, and it's something I choose to *try* to give because I don't believe there's any other purpose. There's no meaning to life. The only meaning to life is to try to destroy all the meaning we try to place on something which is so *profoundly, extraordinarily in itself, that it requires no meaning*. Then we can start existing, not *imagining* ourselves to exist. **We simply represent life; we're not life.** We have become, within a framework of Greek philosophy, representations of life.

And that's only a partial thing. That's why we're so specific, that's why we can't love each other. We can only love *specific* each-others. We're not capable of giving that greater love that makes no judgment, which is utterly unconditional and wants nothing and needs nothing. We can't break this Cartesian, "I

think, therefore I am." We've already separated ourselves completely. We've defined ourselves as separate from the very thing that holds us dear, nourishes us: life. And actually, I think there's a line about it in one of those poems I read—we're denying ourselves immortality. We are immortal, we have existed throughout all time, and we do exist through all frameworks, through all imaginings of time. There's only one thing that actually prevents that, and that is the absolute deceit of "I think, therefore I am." **The moment you think, you're *dead*...**

▎VV: Are you talking about the Second Law of Thermodynamics, which is, "Matter cannot be created or destroyed"?

■ PR: Yes.

▎VV: Well, I'm coming from a standpoint that the greatest philosophy of the 20th century is Surrealism—it really wanted you to bring out everything in your unconscious, all these talents you didn't even know you had. That's why they gave a word to *automatic writing* in which you try not to censor yourself. **You sit down with your pen and paper and do your best to channel creativity—words, lines, drawings, whatever—in the absence of any moral judgment or censorship.** I do think everyone

is an artist, every person is a poet—

■ PR: *And* drummer.

▮ VV: Yes, thank you! Oh, really? I don't know about *me*.

◗ Woman: You're a piano player.

▮ VV: I'm sure there's a lot of musicians in this room. I wrote an article recently about an artist, Llyn Foulkes, who's more famous as a painter, but whose real passion is making music. He did make a statement that making music is one of the only times when he's "happy." (I don't think he used the word "happy"—I'm very cynical about that word.) Whereas he considered making a painting a lot more painful than making music, which is obviously in the moment—you're playing whatever is inside you. As a drummer, aren't you doing that? You're not totally, 100% pre-scripted when you play music. You play and you can change and improvise, depending on whom you're playing with and the room.

■ PR: But if you're creating, if you're suffering pain in creating the painting, then you're not creating a painting: you're creating pain [laughter]. And that seems to be a silly thing to do. And it certainly is something that I did for a large amount of my life.

I didn't seem to be able to separate existential

angst from the art of creativity. I had to suffer. That is something with a very Bohemian tradition that I adopted as a lifestyle, and I lived very unhappily, to be honest, until a year ago.

When I say "unhappily," I was very happy to be unhappy because that's how artists were. I enjoyed it. And now, it's only been the last year of my life that I've been absolutely free from that and realized what total nonsense—it seems sad to me in a way that you have to get to 70 before you start growing up. But it's good. It means you've got it ahead of you, and I wish you luck with it. Maybe you'll get there faster. Or maybe you're already *there*, and I'm just a really slow learner. I'll not say anything more.

❙ VV: Well, I think you "channel" when you play, and you're channeling something bigger than you, perhaps, something "universal"—

◼ PR: Yeah, the next movement is when *you* stop saying, "*You* are this, and *you* are that," and you just let it get on with it. I've learned that, and how I might try to intervene is always an encumbrance. It's an encumbrance to everything. It's an encumbrance to real relationships, encumbrance to real art, encumbrance to real *bread*... *Everything* is encumbered by our sort of slovenly, sloppy, self-interested natures. I don't

mean human nature. I mean the developed, restricted nature we're handed at school in all the definitions, or handed in church in all the definitions. All of those things are just encumbrances: *who we are, our names…*

Everything is an encumbrance. We're simply signifiers until we *cease* to be signifiers. Who the f*ck cares? I don't want to waste my time because it isn't even my time to waste. The moment when one starts getting into these "you" considerations—I can't remember quite how you were phrasing what you were saying—but already you're presenting this thing-in-the-way-ness. And that thing-in-the-way-ness is our ideas of each other. Well, those are the very things that stop us from actually being each other in the deep sense, and that's really what we're here for, but we are doing it anyway. That's what's so stupid. Why do we have to do it separately? We've all gotten here.

▌ VV: One of my favorite statements from the Wobblies is, **"An injury to one is an injury to all."**

▄ PR: Yeah, totally.

▌ VV: I know you recently used the word "universal" as a goal in what you're trying to—

▄ PR: Get out of the way so that it can exist.

▌ VV: ...trying to surmount not ego, not personal, but... What your point was when you were talking about "universals"?

▉ PR: I used to believe that it was only through the specific that one might be able to achieve the universal. That has been one of the very common deceits of poets in particular and the muse. Many, many poets and philosophers have had muses, and I held the belief that it was only through that sort of physical relationship with the muse, by coming together in this very specific, even tense, relationship—and I have to say largely through sexual intercourse—that one came out the other side into the universal. Actually, I realize now that was just justifying my own *licentiousness.*

What I realize now is that the very thing which I was seeking and projecting primarily on women—but it could equally be projected onto men but less often—was that they somehow *earthed* me. On the other side, I moved into the universal. "The Black Book," which is gone now, those were poems of love about exactly that. It was only after I finished those poems that I actually began to realize I had taken a severe—I hadn't gone "wrong"—you can't go "wrong" in life, you simply go where you go and you come

out the other side.

Having come out the other side, I realized the very thing I had always been looking for was what I had never—I was looking in the wrong direction. I was looking *out*. I realized that **the very person I was looking for was the person within**. And that was the great instructor. What I'd simply been doing was laying my love on people in the hope that I'd get the reflection that was already *screaming* to come out. I suddenly understood yearning, that sense in the belly when you feel that massive pull. I don't feel that anymore because (and I call it "she," maybe that's a sexist thing to do, but this fairy, this beauty, this angel) whatever is within me is at last at peace. We're together, and my duality is gone. And that duality was quite simply because I was *projecting* all the time.

And so modern psychology, with this whole idea of *mirroring* and whatever, I really have no time for. That, again, is placing *us* into the picture, and I realize increasingly that the more we remove ourselves from the picture, which is sort of impossible to intellectually describe— you see it in a lot of Tai Chi moves and a lot of Yogic moves as well, *the removal of*—the force that's coming at you is actually the very Self that

you're attempting to push aside, etc etc etc. Gee could probably talk.

▮ VV: You used the word "angel," which brings us back to Gee and the name of the film. Even though I hate Christian religion, I still kind of like the idea of the angel. A long time ago I read a list of the "Top 200 Ideas" people had ever come up with, and the word "angel" was there. I don't know, Gee, if you want to comment. That's the name of your film!

▮▮ GV: Angel is the name of my great-niece, so it's as simple as that. For me, it's about just never losing the child within, because children…we've all been there. They're totally unconscious of themselves. They're totally taking in everything they try. Leave them alone, and they have it. To *lose* that child within—to me, I'd die. Why would you want to give up such joy of life that most children have? You don't want to give it up, do you? If you want to climb a tree at 90, *do it!* I can't think of it in any other way. This whole thing that Penn describes, for me it's **the inner child. I don't want to lose it, I don't think I've ever lost it, and I don't know what it is, but I do love life.**

I love waking up in the morning and having another go at it, really [laughs]. I can't talk about

it in the terms that Penn—I think I understand what he says most of the time, and keep up with it, but they're not *my* words. I can't describe it in that way. But for some reason, I feel I understand what's being said, but it's not my path to it... If anyone has a question—

▌ VV: Let's take that man in the back.

▶ Man in back: How old is your niece, and did you shoot this film in one shot or in different—?

▌▌ GV: One shot, yeah. She was eleven at the time.

▶ Man: One shot? How long is it when not in slow motion?

▌▌ GV: Uh, just about an hour, here and there, because her sister kept making her laugh.

▶ Man: What was she looking at? What was the dialogue you had with her while you were filming it? What were you telling her?

▌▌ GV: She's a very patient child. But I couldn't ask her sister to sit still for an hour; she couldn't sit there for a *minute*; she's the very opposite. Angel is very patient. I asked her to keep as still as she could and just look at the camera, so that's what she did.

▶ Man: What about when she smiled? What were the jokes?

▌▌ GV: Well, her sister was in the room some of

the time, taking the piss. So she would laugh and roll her eyes. It's funny how you can add sound and stuff and make it do something different. You can play with that for the rest of your life, really, because sound put to an image—well, we know what Hollywood does—it puts sound to *everything*. But it's interesting how everything changes. In fact, the film I was going to make with her was very different, but there you go. You have to go with where it takes you.

▌ VV: Well, what's that film?

▌▌ GV: I don't know, I haven't done it yet. I should do it, another version of "Angel."

▌ VV: So is this kind of a meditation on silence? Do you think that's part of the project of *Angel?*

▌▌ GV: No, not really. I don't know—I think it's what you want from it. I mean, I've done it to the best of my ability, and it seems to say what I wanted it to say, but I can't dictate what it says to *you.* It's up to you, really. You might hate it. You might be bored to tears. But that's how it is, so that's how it has to be.

▌ Jennifer: So, in regards to Crass being "spiritual," one of the great philosophers of our generation, Ken Wilbur, said, "Authentic spirituality is revolutionary. It seeks to shatter the world, not console it."

▌ VV: Maybe it can do both.

▶ J: So yeah, Crass can totally be spiritual.

▌ VV: Yeah, well, one reason I like *these* two so much is because: this is my real life, this is not high-falutin' theory or Platonic ideals—these two have stayed at my house, and you can't believe how quick they are to do the dishes [laughter]. More than any other guests I've had. And in fact, they taught me that while you're cooking is the best time to be cleaning off the stove and the sink instead of just standing there like a dummy. I think this is just a tiny bit of what I consider "**the wisdom of living with other people**." And at their house, their toilets are actually clean. Everyone tries to be responsible not just in words but in *deeds*. And it's a different kind of engagement. I don't want to use the word "Buddhist" philosophy, but there's something very considerate of the *entire* household, not just your specific emotional imperatives of the second.

So, we could go on, but in my perfect world, every person in the room would be able to at least personally look into these people's eyes and say a word. So with that thought in mind, I better close the evening off with really sincere, deep thanks to Gee and Penny for being with us.

■ PR: I'd just like to thank all of you for being with us and for all the friends here who've helped us be here. It's an honor. We really appreciate it.

After Emerald Tablet event. Gee Vaucher artwork in background

■ ■ ■

Catching up: One More Conversation

❚ VV: Let's start with *inspiration*. You know, people are always asking this cliché, "How do you get ideas?" What do you mean? There's a million projects you can do. You can't get them all done before you croak—
■ PR: No.
❚ VV: But coming from a Surrealist background, I try to be open to chance and random input here and there—

■ PR: Yup, I don't work from anything else. I don't think inspiration, like awareness, like enlightenment, are things you can go get from the shop, and you can't *do* them from the shop of your mind—I think they quite simply are you *not* being in the way of them. So any sort of planning is going to destroy it—you can't *preempt* yourself, so why even bother to do so... why sort of attempt to create a *structure* for it?

I know **most of my ideas come quite early in the morning when I'm sitting in the garden sipping a coffee, not knowing what the f**k to do next**, which is *why* I'm sitting in the garden sipping a cup of coffee! I haven't got a plan. If I've *got* a plan I've already destroyed any possibility of *actually* coming up with a poem, or making some bread, or doing whatever I do. Because plans are like greasepaint that won't come off... they determine your direction in a strange way. So the less one *has* to do, the more one is open to *do* things. I just don't think inspiration can be *courted;* well, in a funny way I suppose it *can* be through the use of stimulants and that sort of stuff, which do the same thing: they knock you out of the way of yourself. But I don't do that.

■ VV: —and you don't do them because of the

long-term bodily/brain damage potential or—
■ PR: Yeah, that, and also because I don't trust, or couldn't trust, the *outcome*. If I go to or am in that space that allows insight, then I've arrived there *under my own steam,* even if I've done it by *not* attempting to do anything whatsoever. Whereas the moment I've popped a pill (or whatever), then basically I'm going off on a journey, and frankly, if you don't know how you got there, you *haven't* got there! I've met so many bloody—particularly acid casualties who think they got there, but they don't know *how* they got there, so they're actually *lost* in where they've got to. They're dumped in a completely alien city, for example, and don't know at all how they came to be there. Well, that might be sort of a cool and groovy way to be, but it's not *my* idea of fun. I go much more for the "sitting under the tree, waiting" line.
■ VV: At least you've *got* a tree (and a garden). We don't all have that, but we use what we've got—
■ PR: Blank walls, and your couch—your couch is the most decidedly wonderful place to sit and let ideas flourish.
■ VV: I go there first thing in the morning and write in my notebook and try to be open to

ideas and words coming in. You know, "idea" is a "funny" word, I realized, because sometimes weird word combinations show up and then *they* turn out to *be* an idea. For example, I was looking at a cemetery on my trip to Europe a few weeks ago and apparently **I uttered this phrase: "Beauty over convenience." But if you analyze it, what does beauty have to do with convenience?** You understand—?

■ PR: I *absolutely* do, because I've *always* put "Aesthetic Before Practicality," which is almost exactly the same phrase. I've always done that. I think it's more important to have a beautiful table with nothing on it (in other words, no food), than food and an ugly table, because *I* can't eat in ugliness. Whereas I *can* sit and feel joyful in beauty. I also understand that that's exactly how I come up with "things" and quite often don't understand them at all—which generally is an indication that they're worth writing down! I tend *not* to write down what I understand, because if I understand it, why should I write it down?

■ VV: Because you have a bad memory—that's why.

■ PR: No no, I don't care, **my attitude is that if I don't remember it, it's not worth re-**

membering... and believe you me, I forget an awful lot! No, I very much feel that that's exactly how I work. Sometimes I think, "What the f**k's that meant to mean?" but then it comes, and since I've started doing serious *zazen* (as opposed to just *thinking* I might be doing it), I've found more and more I get exactly those sort of insights thrown into my head... and then in my sort of daily life I can sit down and work out what they mean. *Time* will work out that, *I* don't need to be doing it.

■ VV: I think that *later,* if you let some time go by, then suddenly it pops into your head what it *might* mean—

■ PR: Totally, I absolutely agree. I think it's ridiculous to struggle with the meaning of *anything* in ideas, you know: you're ready for whatever you take on, whatever comes at you, and if you're *not* ready for it, it just drifts by. Most of my worthwhile work I can't understand at all, for maybe up to—it seems to be somewhere between ten or twenty years—to *completely* understand what it was I might have written ten or twenty years earlier. That's not the case with stuff like journalese, but certainly my creative writing I don't understand *bugger all* about what I'm doing—I'm just doing it; it's just happening.

If I'm doing a novel I don't know where characters turn up from—*I* didn't think of them, *I* didn't create them—it's almost like they have a complete life of their own. They just pop up and say, "All right, now I'm in this book—*write* about me!" And I don't depend on that—or *not* depend on that—I just accept that "**life is what happens when you're making other plans.**" I mean: why bother to make plans? *Life's* going to get on with it, so…

▮ VV: I like that phrase: "Life is what happens when you're making plans"—

▰ PR: Well, it's attributed to John Lennon, but actually I think it's an old Taoist expression (in slightly different words) which Lennon made into a song. I've always very much taken that line; I think it's so true. Because **plans are an attempt to deny the temporal nature of life, aren't they?** They're sort of ways in which we try and build brick walls out of thin air, to give ourselves some idea of *substance*—and they're all completely unnecessary. Actually, the more substance we have, the less substance we *actually* have, 'cuz we're denying all of that which isn't a particular choice we've made. *Let it flow, and let it happen,* I guess. [chuckles]

I think intent gets in the way as well, you

know. Intent shouldn't be… I mean I had the intent of devotional activity, but what that activity *is* I do not have intent about. In other words, I am not making the choice. I sort of do believe that it is only through *devotional intent,* and that being the *only* intent, whether it's crapping or having a bath or writing a poem or driving a car or standing on your head on the beach or whatever it is… *devotional intent:* if we've got to have anything at all, then *that's* something that's worth having.

▮ VV: I don't know what "devotional" means. It sounds like some sort of "religious" word. Does it mean, like: "Be here—in the moment—now"?

▮ PR: Yeah, sort of an *absolutism,* really. I mean, "devotional" does have religious undertones— and I'm not religious—but I'm happy to use that word because I think it's the correct one. But you could equally use the word "absolutist," as in "an absolutist intent." In other words, ***complete engagement* in whatever it is one might be doing, whether it's sleeping or waking, living or dying**—complete engagement. And yes, that has a long tradition within the sort of "here and now" thesis. I don't mean one needs to be thinking about the "here and now" if one is actually *within* the devotional absolute. You don't

have to be worrying about what are essentially philosophical ideas like "Be Here Now" (which is essentially a *philosophical* idea and not a reality)... because if you *are* here now, you wouldn't be *thinking* it! [laughs]

▮ VV: But that "Be Here Now" phrase can quickly bring you to the present—

■ PR: It certainly can, but I actually do believe that what could help you to the present is something that is not a philosophical idea but actually a practical application. Through *absolute devotion* then you actually *are* in the now, because you can't be absolutely devoted unless you are—so that's a *practical* approach. Whereas the "Be Here Now" is a philosophical instruction, *and* leads to the same place—I mean, I totally accept that. But **I just *prefer* the sort of *poetic* form of the journey rather than the more described philosophical and material way of arriving.** I think the results are the same and the ideas are the same.

▮ VV: I say, "Poetic Over Philosophical," but I think they're both very important.

■ PR: Yes.

▮ VV: And also, instead of your language, I use a different word. I say, "Obsession Brings Completion," because if I'm totally obsessed with a proj-

ect, suddenly it's done!

■ PR: That's again, the same thing, but instead of your word "obsession," I would use the word "devotion." But again it means the same thing. However, if someone else were talking about "obsession," I wouldn't say, "Well, I think that's the same as what I call devotion," because a lot of obsessions can be quite unpleasant things! But my experience with you is hat you don't do unpleasant things, so I can go along with it!

■ VV: Now, I think part of our big project in life is—I realize I got it from Burroughs—it's like an almost **second-by-second, minute-by-minute, hour-by-hour, interrogation of language**. In other words, I'm constantly interrogating the language that I use. **We've talked before about trying to avoid the either-or word pairs** like good/bad, right/wrong, or George Bush's "Either you support *us,* or you support the terrorists."

■ PR: Absolutely. I'm more and more heading towards—the word that is bandied around probably more than any other word is *"democracy."* But **"democracy" means absolutely nothing.** Democracy is whatever anyone wants to make it into for their own convenience (or inconvenience; generally for the inconvenience of *others!),* and it has no actual meaning. I realize

that, and it's very easy to say the word "love" has actually no meaning within the context of the material world. I mean it has no belonging in the material world—that's sort of in a way *too* complex—but yet we continue to use words— that's the strange thing.

And actually it's bit like everything: as we start peeling off the layers, almost certainly we find that almost nothing has any meaning whatsoever, so let's leave it at that. I think that's really rather the case, anyway.

▮ VV: Well, obviously we use words and we imbue them with meaning so that we can keep going and make a vain attempt to communicate one hundred percent, when really we probably communicate less than eighty percent at any given time.

▮ PR: On that question of sort of *semantics*—the whole f**king thing's a "semantic," you know? And it's absolutely true that to arrive at the sort of Buddhistic view of *emptiness,* one has to go through all the linguistics, firstly, which is the way of respecting language, but *then* understanding that all linguistics is semantic, and then understanding that semantics is just sort of like *birdsong,* and then understanding that it doesn't mean anything whatsoever except for whatever

it means—which is nothing at all—except that it's *happening*.

▮ VV: Well, it *can* mean something. I mean you can come up with almost random combinations of word-songs (hey, is that a pun on "birdsong"?), like, "birdsong in the English twilight" and you can almost *hear* it for a second.

▬ PR: Yeah, you *can* do that. I was thinking about exactly that sort of thing earlier, and I'm trying to think what I was thinking about it! You know, they're all actually sort of *sentimentalizations...* which are *fine,* and they're very enjoyable. But, they *are* sentimentalizations, and actually they're going to differ in any case: some people might have had a *good* experience in the English countryside at dusk, and others might have had a very *nasty* experience in the English countryside at dusk—

▮ VV: Like encountering the Moors Murderers—

▬ PR: Yeah, absolutely!

▮ VV: I think of, not exactly Thomas Hardy novels, but John Constable paintings—

▬ PR: Yeah, I can understand that, and that's fine. We tend to assume that it's a form of *genres,* and one tends to hang out with the type of people who might probably vaguely concur with that. But, some people find Constable absolutely

vulgar and ghastly and it reminds them of everything that was crap about "rural life." There is no "general" within… there's no *constant,* and—I remember what I was thinking about. I was asked this question about "beauty," and how there seems to be commonly accepted ideas about beauty. And yes, they are commonly accepted, because we are commonly conditioned in certain ways.

We have the "Hidden Jerusalem," and "Did those feet in ancient times… walk upon England's green and pleasant land." Well, that is very *key* to our whole cultural approach: here we are in this green and pleasant land. Well, actually, it *isn't* that green and it isn't that pleasant! Unless you make quite an effort; generally speaking, it's concrete and shopping malls—*that's* what we experience in most of our lives. And **we might take two weeks' holidays in the green and pleasant land… which increasingly is becoming heritage-ized and tourist-facilitated.**

But that's the dream, and that becomes our sort of standard idea of this place—I'm *exaggerating,* obviously. But we do that with everything; we do that with our friends—we exaggerate their properties, and then lean on other people to concur with us. Which is why we go around

doing all that *nitter-natter;* we'll say, "Alex is a really nice guy," and we're not actually saying it because we think Alex is a really nice guy, what we're trying to do is *confirm our thinking through someone else.*

And if someone says, "No, he's not; he's an absolute bastard," we feel a little bit taken aback. And Alex isn't even there to say, "Well, why don't the couple of you just shut the f**k up?" Actually, what's happening is: *we* are trying to establish *ourselves* as a set of ideas we have *about* ourselves, and asking for other people to concur with us, because that's a nice way of feeling we've got some sort of *substance,* I guess. Rather than accepting that we have none whatsoever, and it doesn't matter a *bollock* what anyone thinks about Alex, because Alex is just going to be thinking about himself.

▌ VV: That's for sure. Everyone is on their *own* trip. You used the word "dream"—tell me, have you had any lately?

▐ PR: I don't *like* dreams, and I have had a few. I don't like dreaming.

▌ VV: That doesn't matter; they *exist.* They happen.

P: They do exist... I go to bed to go to sleep. I think enough during the day, and I get enough of

things to look at, and things to play around with, and I go to bed so I *don't* have to do those things. Cuz I go to bed *to stop the day.* And I don't really like the day *invading;* that's very rude. I just wanna be nowhere when I sleep!

I can't remember what my last dream was, but I had been dreaming a little bit recently.

▌ VV: Well, the Surrealists say that **dreams are often the source of poetry and painting**—

■ PR: They never have been for me! In the same way, I've written two poems under the influence of alcohol—

▌ VV: Drink? I didn't think you did—

■ PR: I used to drink—yeah. I used to drink a lot. Also, I've always attempted never to write when I am upset. I try to make all of my creative work come from a stable position. I don't want to be *pissed,* and I don't want to be *pissed-off...* because then all I'm doing is a piece of therapy. And I'm not really interested in doing pieces of self-therapy—I do that in other, more practical ways. If I'm f**ked-up, the best thing to do is go and weed a path, or make some bread. I'm not into making art out of one's own pain; I'm not interested in that—

▌ VV: But what about your drawing—that's not even verbal—

157

■ PR: Quite simply, I think that if you're up-set, then you're going to be incorporating that upset-edness into it. Francis Bacon would be a very good example, in my view, of someone who was just sort of passing on *his* f**k-ups to other people in a sort of f**ked-up way. I mean, I re-ally don't enjoy having to sit around and look at other people's f**k-ups.

The last time I was in New York I went to the Museum of Modern Art 'cuz I wanted to have a look at a Jackson Pollock. And in the same room they had a Francis Bacon painting which I just couldn't *believe,* because on the one hand it seemed to me that Pollock sort of pushed every-thing *way out*—you can't "consider" it; it simply *IS.* Bacon: there it was; it was a little like seeing someone stuck a crucifix... something unpleas-ant which was meant to try and say something; I didn't like it. I don't like being preached other people's f**k-ups—that's a good reason for not liking Christianity, isn't it, really? However sort of nice and charming Christianity might be, it's still based on some bloke hanging uncomfort-ably on a lump of wood—I don't think that's a very good *image.* It's not a very good lesson, not a good example; it doesn't help; it's ugly.

■ VV: I certainly would agree. But I kinda dis-

agree with you on Francis Bacon. His "Scream-ing Pope" series of paintings: I think they are an extremely hard-hitting critique of religion—

■ PR: I don't "read" them like that. **All I've ever seen in all of Bacon's work is his pain.** He can put that into some sort of slightly more clever context, *but*... Someone was being abu-sive in a restaurant last night, and I just went up and said, "Do you understand every abuse you've made of other people is more importantly an abuse of *yourself;* will you just shut the f**k up, please." I see that sort of presentation of neg-ativity—negativity is basically abusive, funda-mentally abusive. But actually, the only person it really hurts, in a true sense, is one's self. (Well, actually you *can* do a certain amount of damage to people around you, but...) Um, I don't need it hanging on a gallery wall!

■ VV: Well, that may be, in my eyes, a bit of a simplistic interpretation of the *opus* of Bacon, but we can proceed from there.

■ PR: I might have to be sitting in your apart-ment a long evening on that one— [laughs]

■ VV: I look forward to that happening! Because I'm positive that because you're so vehemently against dreaming, you're going to have a won-derful dream! Sometimes dreams are just fan-

tastic, involving foreign countries or places like Hawaii. Quite regularly **I have dreams where I am swimming, but often I'm not in the water, I'm about a foot above—**

■ PR: You're flying, then!

▌ VV: Yes. But it's a wonderful memory. It seems so real.

■ PR: That's it: it seemed so real. Uhm, the dream thing just doesn't *take* me. I've never been into dream interpretation. I've always sort of figured that dreams are a bit like: during the day we eat loads of food, and the next morning we crap a large amount of it out—stuff that we don't need. So dreams are sort of like *mind excretion...* getting rid of the stuff that you can't deal with, don't want to deal with, or haven't got any time for. And I don't think there's any lesson to be learned; we don't sort of analyze our sh*t when we've just had a crap, generally speaking—unless we *are* an "obsessive." I mean, I certainly don't start fiddling around with my crap in the morning. And I feel the same way about my dreams: they're just getting rid of the stuff that I couldn't process. Which is why I say: if you do too much of something during the day, you might dream it, because actually, you've *overfilled.* So what do you do? You dream it out.

I certainly used to get dreams when I was a mountaineer, because you spend such a large amount of time tying knots and pulling ropes. I used to have "tying knots and pulling ropes" dreams, and that's because I'd probably been pulling a rope most of the day, and tying a knot for about 1/8 of a day, or checking that a knot had been correctly tied. But what happens at night-time is: I don't need *that* in my brain. So it just comes out as excretion, as sh*t: a dream. That's sort of *my* fundamental idea about dreams. The Surrealists can do what they like with dreams; that's fine—

▌ VV: They turned 'em into paintings and literature—

■ PR: Yes, I know they did. And in truth, an awful lot of 'em are pretty crap paintings—

▌ VV: Your opinion, sir!

■ PR: Yeah, in my *very good* opinion. [laughs]

▌ VV: I don't analyze dreams; I just have them. And sometimes they're almost a little prophetic (knock on wood). But that mountaineering dream I can relate to; I've had that kind of dream where I'm obsessively—I used to be a typesetter, and I had dreams where I was obsessively trying to get the type "perfect" but the kerning was never quite good enough… But in your moun-

taineering dream, well, fear is a very important almost *drive,* or something, and your life depends on tying the correct knot perfectly, every time. So you had "trying to transcend fear" dreams—
P: Well, dreams possibly are "trying to transcend fear"—I wouldn't disagree with that. **But *I* see fear as being the *cohesion* of the material world, because it's held together through fear.** If we had no fear, then we would not have the sort of tight definitions and tight parameters we have within the material world to actually control our idea of *substance.* And actually, that would have been a pretty Surrealistic view: that beyond the parameters, beyond the definitions, anything can happen. And the fact is, **the thing that stops anything from happening is FEAR.** Which is why social control is based on fear. It holds us within the defined parameters of any given culture, and if we step outside them we're going to be in trouble. So we don't. We're *afraid* if we step outside, we're going to be in a mental institution, or have a gun at our head, or whatever happens to people who don't conform to their particular cultural references. And the Bohemians get away with it—but *just.* They do get away with it—

▌ VV: That's where we are—

■ PR: That's right, dancing around on the edge of it—

❚ VV: We're not dancing around on the edge of it, we're trying to be at the frontiers of what you might call "acceptability." I grew up being told to become a doctor or an engineer; it wasn't even an option to become an "artist" or a "poet." That saying: "**Your Only Free Will Is Your Power to Say No**": I think a great deal of life consists of learning how to say NO in many, many, many different ways.

■ PR: I think that's actually true; I think there is a YES within the equation, though: you could call it the Alice's Looking Glass Syndrome, or the Rabbit Hole, because basically she sort of hurled herself into a different dimension, if you like, or a *bigger* dimension, that carried the same sort of configurations as the one she was leaving behind. It became much more sort of fluid, much more expressive, less defined. And by being less defined, there's more in it. You have disappearing cats, speaking rabbits—all this "stuff" that happened in Alice stories. And that's through saying YES, equally.

So I think within the material world it's a matter of saying No, but then actually when one comes to the sort of *existential wall,* it's a

matter of not saying No but actually saying Yes and walking straight through and falling down the rabbit hole. And then life starts opening up into a far more varied, far more colorful world... which is exactly what I've always felt Surrealism was about: sort of dropping through the brick wall and falling down the rabbit hole.

▌ VV: When you're reading the Complete Works of Lewis Carroll, you're almost there when the words enter a kind of *sound dimension* rather than a *meaning dimension*—

■ PR: Um, huh—

▌ VV: And the sounds start suggesting other words... it's like sound is a path to—not exactly poetry or philosophy, but it *may* be... just the sound dimension: you can sort of float along on the wave you've created, like with surfing...

■ PR: I'm sure that's true. I was thinking something about music. **I was just listening to Brahms' Alto Rhapsody** on the radio, and it was along those sorts of lines. Because it's almost impossible to—you can't grab hold of a bit of a symphony. You can't grab hold of it; that's how it works. It works just by the fact that you *can't* grab hold of it—you're listening to the *next* bit, which is in relationship to the bit before, and the bit after that also is *itself*... And we

sort of just drift along and all sorts of images—**far more images are produced—for me—in a piece of music, than there is in someone talking**. Because someone talking is slightly directing the form of image that I am going to create. Whereas a piece of music doesn't *do* that—I mean, it does tend to push toward landscape more often than not, I think—either an urban or a rural landscape, but it tends to play around with the *grand form* in a way that words—well, most words tend to be much more specific—

∎ VV: Did you say "rural"?

∎ PR: When people talk about "landscape" they generally are talking about a rural, "natural" landscape. But I don't. A "landscape" is anything or whatever you're looking at—it is for me, anyway.

∎ VV: "Concrete Jungle" is a term I learned from some reggae song by Bob Marley—

∎ PR: I think he was using it in a positive sense, but it tends to be used in a negative sense, isn't it? But that's ridiculous. An African jungle is no more or less enjoyable than the Lower East Side of New York, or wherever it is you happen to be meandering around. It's what *you're* taking in to the place, not what the place is giving to you. I've never understood the negative context of

the "urban jungle," as if there's something "bad" about that. I like all that stuff; I particularly like New York because there's so much sirens and road noise, and there's always like rivers and birdsong in the African jungle—it's so much the same sort of noises: brash and loud and traffical. So I don't see the difference…

▌ VV: Well, we'd like to call it a poetic thing. Remember "No separation between Poetry and Life"—

■ PR: No, there isn't. Well, there is, 'cuz most people try and make a separation. But there really can't be, can there? Because basically, there's No Separation Between Life and Life… because Poetry Is Life, as is Bread-Making, as is Working as a Banker. It's just that we ascribe importances to things and lack of importance to other things… That's applying strictures on *ourselves*. But if we are truly poetic in life, we are *living* life. And it might mean we knock out a poem, or it might mean we go and have a crap—it doesn't make any difference. I like the phrase, "Life Lifeing Life."

▌ VV: Well, I kind of differ. I feel that **words and images exist on a parallel plane to "reality," and that so much trouble is caused in the world by people confusing these separate,**

parallel planes—

■ PR: I actually think that the material world, or the *given world* (another way of saying "the material world") is no more than a set of words. Those words create form. There is no form except that which is defined, and it's defined through common agreement. Again, that's what the Surrealists were buggering about with, because basically they were saying, "Well, I don't actually feel like that," or even going as far as saying, "It isn't like that." In that sense, Cubism was Surreal in the sense of seeing something from multiple facets, which we imagine we *can't* do, but actually we *are* doing. It's only a way of choosing...

▮ VV: I would say that **Cubism was pre-Surrealist, before the word "Surrealism" was invented—**

P: Absolutely.

▮ VV: In other words, I'm always trying to get *behind* words... Sometimes you're not sure which exact word to use when you're writing—

■ PR: That's a bit of an indicator, because if you can't think of a word, that's actually the space of *being*. Whereas, "Well, I can't think of it, so I'll put a whole thesaurus there" isn't actually an answer to the problem. It's a bit like saying,

"I don't know how to make love, so I'm going to make love to everything and anything that comes my way, whether it's a grapefruit, or a girl, or a boy, or a pig, or anything else." I mean, that's a bit of a crap way of existing; I don't think that's good. It doesn't make any sense to me—

▮ VV: Especially if it's a huge cockroach—

P: Yeah, yeah! [laughs] I've got far more respect to the sort of Cut-Up Idea—"Well, I don't know where they go anyway, so I'll just cut 'em up and put 'em in any ole order—that's fine, that works."

▮ VV: Do you do Cut-Ups?

▮ PR: I have done, of course. But what I'm saying is: I've got a much greater preference for taking *that* approach (in other words, the sort of random approach) than I have for the over-considered self-consciousness of saying, "Well, I don't really quite know which word to use." If you don't know a word, then don't use it, because you can't—you don't *know* it. That was something my brother told to me very, very early in my writing life: **"Never, ever, use a word out of a thesaurus that you don't actually use in everyday language."** That was a very good tip… because you're gonna use it wrong. Until you've incorporated a word into your *being,*

you might mean something and you will mean something very different—you know, you and I use words ever-so-slightly differently because of our experience, but there's a sort of common acceptance. There's no *absolute* in words, that's for sure—there cannot be. So, we're just playing around with that—we're just, in a way, *hoping* people will understand what we mean by a "tree."

▌VV: "It seems to me/ there will never be/ a poem so lovely/ as a tree"—that Joyce Kilmer poem—

■ PR: [laughs]

▌VV: And I agree. But at the same time, it's so much fun to play with words—well, you call it "work," I call it "play"—

■ PR: No no, I agree with you! **I was asked in an interview, "What is work?" and I said, "It's play."** And the only difference is: "work" carries a certain sort of *self-important* atmosphere to it, whereas "play" tends to carry a *not*-self-important "ism" to it, so really, I *do* prefer the word "play." What I am saying to someone if I say, "Sorry, I've got some *work* to do," it's a way of saying, "Get off my f*cking back; I'm important; I need my own time." Whereas if I say, "I'm playing," they'll tend to say, "Ooh, can I come

along, too?" If I say I'm working, they *don't* ask to come along, too, because people don't like working. But actually, they're one and the same, and I agree with you on *that* level; we're probably in complete agreement.

▍ VV: Yeah, well, sometimes you've got to put your foot down and say, "I NEED to be alone."

■ PR: Oh, yeah, yeah, yeah—

▍ VV: But you don't say that; you'll hurt their feelings—

■ PR: I do! I have no problem saying that. Particularly living as we do here [at Dial House], where there's a lot of people turning up, coming

and going. **I've had to learn to say, "Sorry, I need my own space"**—which doesn't mean, "Piss off!" One of the things about this place, which you know, is: everyone's got their own space, so they can go to it and be left alone.

At the Dial House garden

■ VV: You can also say, "I've got a deadline," and most people get it.

■ PR: Oh yeah, that's a good one—that's an absolutely good one.

■ VV: Well, when I started publishing a million years ago, a conscious goal was to "**Fight the**

Control Process" that keeps us from being poetic, creative, and playing. And the Control Process has gotten weirder and more insidious. There's what I call a "New Slave Culture" where people are *voluntary* slaves to their iPhones. You're probably not around them much—

■ PR: I'm around them if ever I'm on a train or a bus or walking on a city street. My term for them is "Space Invader," which is precisely what they are. Rather than being in a huge rocket ship, people are actually *in* an iPod [or iPhone]—same thing: it's a lump of technology which has taken over their trajectory. Which is why they don't seem to be able to get out of the f**kin' way when you're walking along the path, or pavement, or sidewalk (the American expression). People bump into you because they're not even *there*—they're in their capsule, and their capsule is a tiny little cigarette-pack-size thing—but they're in it. Their physical form seems to have disappeared, except that they bump into you with it!

❚ VV: I call them "phone slaves"—it's a new culture of slavery, or slave culture—

■ PR: Absolutely.

❚ VV: People don't turn 'em off when they should, like when they come over for lunch. **They ought**

to have some time for themselves, which no one can arbitrarily invade—

■ PR: Absolutely. The "Space Invaders" become invaders, but at the same time *they're* being invaded—I mean, there are so many double-binds in this—

❚ VV: They *are* being invaded by these cancer-causing cellphone signals from afar—

■ PR: Yes, totally! It's sort of a parasitic thing. And then the parasite tends to affect anything around it. In other words, they bump into you—they get in the way. Because they *are* being parasitic. Heathcote Williams wrote "Autogeddon" where he sees cars as being the Master, and people being the Slave to the car. Well, the iPod or iPhone is just a big advance on that, except—it's smaller! [laughs]

We're in a sort of nano-world where smaller and smaller things are going to become the things that have power over us— like tiny chips in the back of our skull. They're going to be very small, and it's going to happen.

❚ VV: You'll be born, and a tiny chip in the back of your skull will be your iPhone, basically.

■ PR: Yeah, and you've got the entire Dictionary of the World and of the Cosmos already there. You've got Google, so you don't need to think

anything at all. I love that business now where people no longer—you ask them a question (*anything,* almost), and they say, "Oh, I'll google it." That's become a new term. It's incredible: you don't need a f**king memory, you don't need a dictionary, you don't need anything—you just need google—

▌ VV: Which is a state of almost *infantilism,* because google sounds like "goo goo"—the sound that babies make—

■ PR: That's absolutely right. It's also an infantile response to a sort of "Grand Authority" that's better than "God"—because "God" seemed to know very little, but "Google": *he's* got the information—

▌ VV: —that makes people go *in formation* (like marching in an army)—

■ PR: Absolutely. When you were talking earlier about playing around with words, so many words do that: you crack 'em up a little bit, and there it is, in your face—

▌ VV: — a new, more "truthful" meaning! **Here you are, being a pawn of fascism, and you didn't even know it.** I'm always trying to deconstruct the hidden fascist structures of language and certain constructs. A lot of this happens on some "sub" levels—like, the revelatory puns are

kind of hidden IN the word—those ad agencies know all this behavioral "stuff" better than us; we should be studying them. They know that **if they put the letter "x" in their ad or brand, whether you know it or not, you instantly think about "sex."** I'm concerned about how we're controlled or directed or conditioned, without even *knowing* it.

■ PR: Well, we're affected by *any* word—any single word is an emotional or psychological construct, *designed* to have certain hidden meanings. And the combination of two is going to have a multiple of god-knows-how-many meanings... it just explodes out.

The very fact that a word exists implies a deliberation beyond *convenience*. Why has it been convenient to define these things that we see as the material world... where clearly, we could see *other* things, or we could see the same things in different configurations. As it is, we tend to see pretty much through *one* lens. And I think "quantum" is breaking that down... certainly breaking down the sort of *rationale* or sort of reasoning of that way of thinking—

■ VV: Quickly, define "quantum"—

■ PR: Well, for me, "quantum" means talking about infinite possibilities, talking about: any-

thing is defined by the *observer,* not by itself. Those are the properties within quantum that interest me more than anything. I mean: particle matter. It is beginning to be believed that atoms have no identity—they have an *entity,* but they have no identity. They're nothing until they're given something *to be.* And, an electron could just as easily be a neuron—it will be whatever it is asked to be, effectively. And that's the nature of "matter," within sort of quantum thinking... that's a ridiculous simplification of it.

But it's so obvious that all of these "things" that are in front of me at the moment: a tin box, a telephone, a notepad, a pencil, a pair of glasses, some cigarettes—they're all sitting on their own. But in particle terms, of course they're not sitting on their own—they're indefinable, they're indistinguishable, on a particle level. And they have no identity on a *particle level.* **It is only through conditioning that I am able to "see" what I am seeing in front of me at the moment**. And that conditioning is because: the people before needed to say, "I want that," or "I need this." And we conform to that, but we don't actually *need* to conform to it; it's just that we *do* conform to it. Increasingly, I realize that not only do I not *need* to conform to it, but that

I *won't* conform to it. And within that, I'm *beginning* to get different pictures; different things happen which *shouldn't* happen. I still haven't gotten used to that—and it doesn't happen a very great deal, but we're sort of headed toward *fluidity,* where a cat turns into a shadow, or a shadow turns into a building, or "stuff" *turns into* ___, rather than being static—

▌ VV: **Everything in life is a work-in-progress, including our theories**. Even material things are in the process of slowly evaporating. We're surrounded by books and notebooks, but in a million years, I doubt that the molecules will be there in their present configurations.

▌ PR: I think that *feng shui* "thing" is absolutely true. Gee decided to tidy up the bookshelves—about every four or five years we sort of do a sort-out: throw out a few books, dust them down. And it wasn't *just* that they had been put back and looked a little bit cleaner—there was an *energetic* coming off them because they'd been re-energized.

There was a Zen tea master who went to the British Museum and the museum people said, "Oh, you must have a look at our Tea Ceremony Objects" (they had little cups, and teapots, and stuff). And the Zen master couldn't actually *see*

them—he could see these lumps of china (or whatever they were made of), but he couldn't actually see them as part of his craft... because they didn't have the energetic anymore; they'd been stuck in a museum gathering dust for more than a hundred years (or however long) and they'd actually lost their ability to communicate. Well, that's exactly what happened with Gee tidying up the bookshelf; it's quite extraordinary: the books are still "dancing"—I can see them dancing, because they've been re-energized. Some of 'em hadn't been touched for years. Each one of them has been taken down, put back, and been re-energized.

▮ VV: Nice idea; **I love to think of books as being "alive."**

▮ PR: Yeah, I think they ARE! As things get left, they sort of *dematerialize;* actually, they turn into some other form of material... because you know we can't destroy energy—

▮ VV: Paper molecules slowly become dust—

▮ PR: They can then take on a different form, possibly. I was chatting with a friend, and he was saying that recently, they've realized that the molecules given off from a dead body of an animal or a human actually *attach themselves* to your nasal passage... which is why it's very dif-

ficult to get rid of the smell of death.

▮ VV: Wow!

▮ PR: Well, I haven't looked into it. Some time I'm going to ask him, "Can you *widen* that? Where did you get this information?" It was some radio show he was listening to; it was a physics professor talking, I think. But I thought, "Okay, that makes so much sense—that's the *energetic* acting in a parasitic way; effectively, "This body is no longer operating, and I will find and attach to one that is."

Apparently, during the First World War, masses of soldiers (guys in the trenches) were writing back home to get lavender oil sent to them, because that's one of the most powerful antiseptics, and also one of the most powerful smells to eradicate other smells. Anyway, within that framework of stuff disintegrating, we're very uneducated or unaware of what happens to "matter" when it no longer is behaving in the form that we like to think it should be behaving. We're not good with that; we haven't got anywhere. And I think that's one of the things that quantum is beginning to come up with for— particularly in that idea of: nothing having an actual defined identity until it's actually given one by some form of *observation*... and then it

will behave like an electron, as opposed to behaving like a proton. And I think that we are much the same: **we hold ourselves together through self-affirmation, self-confirmation, and the affirmation and confirmation of others**. That's how we remain as one lump. So we're actually all propping each other up, in that sense—that sort of *symbiotic* sense—holding it all together.

▌ VV: I'm sure you've read about the Black Plague [Ebola?] and how smelly all the bodies were, and people took to carrying around handkerchiefs stuffed with violets or posies. Doctors wore beak masks which violets or posies could be put into—

■ PR: There was a special name for those masks—they stuck all sorts of different herbs into them.

▌ VV: It's very hard to think about philosophy if you're smelling the scent of death—

■ PR: Absolutely; you're less likely to be doing it—

▌ VV: **As a writer, you are your own disciplinarian.** That's a variant of your CRASS saying: "There's no authority but yourself," but there's also no disciplinarian but yourself.

■ PR: Absolutely. If I'm going to perform a piece

of work, then that's entirely and precisely and completely what I should be involved in. It's concentration of thought. Other people seem to find this rather difficult: this idea of self-discipline. Vigor is another one—

▌ VV: Did you say rigor?

▌ PR: No, *vigor*. I did a big gig last night; it was a very energetic one. Then in the morning one of the women who was in the audience turned up and we went picking apples for an apple festival. She said, "I can't believe your vigor." And I said, "It only comes from one thing, and that's the sort of desire to…" really, let's go back to the devotion "thing": Be Kind. Be kind by passing on… **I think it's almost a sort of moral responsibility to put on a good show**, whether it's on a stage, or whether it's on just the stage of the everyday: **Look Good. Sound Good.** Don't start moaning about it. It's all part of the big picture, isn't it, because that's what inspires people; that's what makes people think, "Oh yeah—*I* can do that! Great, let's go on with it!"

▌ VV: I agree.

■ ▌ ■

INDEX

Printed in the USA
CPSIA information can be obtained
at www.ICGtesting.com
JSHW012121140224
57425JS00003B/5